D0581841

Brad
Downey

Spontaneous
Sculptures

gestalten

Index

Method

Material

Location

Duration

Year

Mel Gooding

Sign City

In SIGN CITY, every gesture / each subtle nuance / all seemingly invisible motions / slight indications / signals / any moue tic / tic-tac / tell-tale flicker of expression / by-play / almost unseen dropping of jaw or batting of eyelid / unnoticed twitch of forefinger / crossing or uncrossing of legs / sniff / jiggle / incline of head / flexing of calf muscle / jut of chin / meaning look / expression of face / darkening of brow / hint of smile / casual glance / almost imperceptible frown / rise of eyebrow / narrowing of eye / pursing of lips / tensing of shoulder / stiffening of lip / clench of teeth is registered / read / each fine shade of every possible meaning subject to nice precise particularities of analysis / de-briefing / every last intimation of possible indication of feeling / minute sensation / least stirring of a prompting to small actions / weakest impulse to feeble irresolutions of violation / velleity / veiled whisper of expression / merest accent of emphasis or de-emphasis is checked / matched against exhaustive gesture data / pose examples / position registers / entered into manuals of manual motion / catalogued / coded / banked / ranked / measured in extent / searched for intent content portent / scrutinized / sounded / logged / its implications extrapolated to potential interactions / interfacings / interlocutions / interrogations / inquisitions / inquiries investigations / speculations / specializations / disputations / contentions / conventions

In SIGN CITY, colour coding has been determined already for the grander, bolder, more expansive, highly expressive, unmistakably unambiguous, four square type hint / gesture / signaling manouevre / waving / shaking nudging / unsubtle positioning / pointing / gesticulating / shrugging / power play posing / actions at a distance / reactions close at hand

Shades of grey are undergoing procedures of discrimination / nuance analysis / classification / categorization / codification and ratification as mood indicatives / nicety of meaning distinguishers / deviations of feeling measures / redundancy registers /

In SIGN CITY, no move will go unnoticed, every gesture will be understood: everything exists to become a sign of something else in Sign City.

Gormley's dick and other urban interventions

Brad Downey's work over the past decade has consistently pitted itself against the sanctioned and the predictable. In 2005, when I was working at the ICA in London, Downey and I collaborated on a mini-bus tour of unsanctioned public art that took passengers around the streets of London to witness live graffiti, street art, a censored historic façade, and an artist reading a novel in a lounger that occupied a parking bay on a very busy street. The context for this provocative event – during which we took the precaution of inviting a lawyer and a local planning officer – was the increasing prevalence of commissioned public art backed by a burgeoning curatorial industry, generous funding, and regeneration tsars.

Artists often benefit from the prestige of media-friendly, big-budget public art commissions, and the challenge to work outside the usual gallery limitations. Public sculpture provides work for foundries, model makers, and structural engineers. But the necessary length of the consultation and production process – the planning laws and red tape, the health and safety testing – means that they end up closer to the category of monument than art. In short, public art often needs to play it very safe and appeal to its local audience, while being grand enough to warrant funding and wider media attention.

Downey's spontaneous sculptures, on the other hand, only last as long as the public or officials care to allow (from 10 seconds, in the case of a cheekily placed plastic bottle that adds a phallus to see p. 62 an otherwise sexless Antony Gormley figure in Stavanger, Norway, to a few days. Some may still be in existence as I write). Sometimes the nature of Downey's materials determines the duration of the piece, like shaving foam on a bollard in Bollard Cover see p. 132 (Chess), Vienna, 2010, or Stone Cover (Meat see p. 76 Street), Berlin, 2011, in which square-shaped salami is camouflaged against cobbled street paving until it is all too quickly sniffed out and gobbled up by a passing dog. Unlike conventional public art, his studio is not tucked away out of view but is on the street, and his materials are the found objects and detritus which the urban environment so plentifully provides: traffic cones, street signs, bollards, shopping carts. Production mingles with the countless road-works being carried out on in the urban environment, highly visible but ignored by most.

Nonetheless, Downey's work isn't strictly categorized within the marketing-friendly term "street art," which presumes a separation from contemporary art and its history. Rather, it is full of witty, sometimes acerbic references to art-historical figures and movements, from Dada to land art to minimalism, pushing the experiments of twentieth century modernist sculpture into the anarchy and chaos of twenty-first century globalized cities such as Berlin, London, and Dubai. Many of Downey's sculptures share the one-thing-after-another serial logic of minimalism, while his use of bricks and paving stones nod to Carl Andre, all the while eschewing the rarefied institutional context this work relied on for validation and a sense of presence. A column of conical ashtrays, another of trash cans, pay homage to Brancusi's elegant monument, Endless Column, see p. 10 1938, while a set of works based on a pile of disused

cable tubes (Tape Lift, Amsterdam, 2008) see p. 114 shares instead the deadpan sentiment of Robert Smithson's famous road trip through suburban East Coast America (A Tour of the Monuments of Passaic, New Jersey, 1967), in which he ironically designates various industrial paraphernalia as monuments.

There's an ironic macho element to Downey's work that takes its cue from the modernist figure of the hyper-masculine sculptor, such as when he turns broken concrete benches into a stark, constructivist sculpture. Following Duchamp, Downey sexes up the most banal street furniture, as with the cheeky appendage of a bollard attached at right angles to a tree trunk in Bollard Tie (Dick), Stavanger, see p. 63 2009, or performs bathetic castrations, as in the case of the drooping Bollard Bend (Limp- see p. 126 ing), Seoul, 2010. Buildings and street furniture are anthropomorphized further in unexpected ways in Downey's universe. Bollard Tie (Healing), Vi- see p. 135 enna, 2010, for example, encourages sympathy for the humble bollard, as just one example of all the damaged street objects that sit waiting helplessly for repair or removal. One broken bollard is even given wooden splints as if it were a human limb. In a particularly extreme case, Booth Pry (Dead), see p. 144 London, 2005, a phone box lies horizontal on the ground – a symbol not just of nihilist vandalism but of a whole sphere of public life that the mobile phone has rendered near obsolete.

Romance and serendipity are two more unusual tropes for a contemporary artist, particularly one working in the public realm. After all, as we have noted, public art is supposed to be universally accessible, not left to chance or based on private sentiment. In Tarp Cut (Ladder-Stick-Up), see p. 80 Aberdeen, 2007, Downey cuts a giant heart from the gauzy material used to conceal scaffolding, in a process that mixes the legacies of Gordon Matta-Clark with Christo and Jeanne-Claude. The scissor work is done from inside the gauze so that, from the outside, it might look like a spontaneous act of love from the building itself.

Humor is also a key element for Downey, who often uses it as bait to catch the attention of the unsuspecting passer-by. He has the knack of creating apparently magical situations, as with Bike Hang II (Perfect Throw III), Essen, 2010, in which a see p.44 bicycle dangles over the axis of a double-headed streetlight as if in a giant fairground game. We are all familiar with the phenomena of the single sneaker

mysteriously hooked over an overhead power cable, but a bicycle? In another series, Downey places helium balloons inside anti-terrorist rubbish bins see p. 54 (clear bags, skeleton framework, almost like a basketball hoop) in Paris, so that the now inverted rubbish bags float upwards – much to the delight of local kids, who then of course steal the balloons (mini Downeys in the making).

One might even conjecture that there is some nostalgia in Downey's work for the fun and freedom of childhood that is perhaps compromised in today's more cautious and less child-friendly society. see p. 70 For Chalk Mark (Hopscotch), Berlin, 2010, Downey chalked the well-known kids' hopping and jumping game onto a subway platform, precisely calculated so that the number 10 box led to the open doors of the oncoming train, and even continued inside the carriage. As a gesture, it appeared willfully naive juxtaposed against the gritted stoicism and stress of commuting.

Downey himself does a lot of travelling these days, so that the geography of his works has become as important a context as their duration. Clues as to their locations (linguistic or design) are not always immediately obvious from the documentary photography, which is often tightly cropped to the sculptures and the situations that arise from them. Yet, occasionally, the work cannot help but reveal the historical or political subconscious of the city, as with the column of precariously stacked bricks in Berlin that inevitably succumb to gravity and topple over to leave a neat trail of rubble. Downey's collapsed monument is particularly provocative in a city that has been trying to brick over its historical scars since the fall of the Wall.

Other works have taken on an archaeological dimension, with Downey appearing to uncover mysterious phenomena lurking beneath the streets, such as the fairytale-like sandcastle in Pavement see p. 158 Pry Sand Stack (Castles Beneath Cities), Amsterdam, 2008, or the graffiti that the authorities had neatly tiled over, but which Downey reveals as if a Roman mosaic, in the ironically titled see p. 142 Tile Pry (Gentrification), Amsterdam, 2008. Latent traces of fascism resurface in a recent piece in Portugal, in which an ornate spiral-design paving tile is subtly altered to resemble a Swastika – a gesture that no doubt would have strong resonance for a country in which memories of dictatorship (until 1974) are still raw.

Some might call Downey's sculptures illegal – which strictly speaking many are – but this risks fetishizing the illicit for its own sake. The fame and high auction prices commanded by certain street artists in the past couple of years are surely linked to this desire for the frisson of the underground and the risky to pep up an ailing art market. Yet, for a society obsessed with keeping its citizens under surveillance, it is incredible how much Downey and his collaborators are able to get away with under people's noses. Indeed, you notice that Downey has become more fearless in public over the years. Where once he took on the persona of a security guard or wore the high-visibility jacket of the anonymous worker, now installation shots show the undisguised artist casually moving street sculpture or re-arranging some road markings.

Downey's work has always carried a strong note of defiance against the bureaucracy and paranoia that governs public space. The documentary photograph for Camera Burn (CCTV Sacrifice), see p. 89 Berlin, 2008, shows gasoline flames engulfing a totemic CCTV camera, a brief symbolic victory against the increasing encroachment on civil liberties and personal freedoms. In Window Smash (Just Taking the Building To Its Logical Conclusion), Ber- see p. 84 lin, 2008, Downey speeds up the process of one deserted building's descent into a modern ruin, smashing the remaining few windows, so that all are now shattered. It is a nihilistic gesture, sure, but only against the inevitable. Architectural euthanasia or necrophilia, depending on which way you look at it.

These few violent works are not gratuitous but important reminders of the tension that always lies behind Downey's working method and the stakes his work carries in a tightly regulated urban realm, even when he appears to wear this tension lightly. Downey made one of his most audacious and graphically striking works in 2007 when, in a moment of postmodern existentialism, he managed to switch off the first letter of a neon SHELL sign above see p. 88 a gas station in his home town of Atlanta. Modern urban life can be HELL, but for this artist, the freedom and spontaneity it allows, even in small pockets, and the huge range of unloved and discarded materials available, continue to provide an endless source of curiosity and potential for a new, as yet uncodified form of public art.

brick [brik]

—noun

1. a block of clay hardened by drying in the sun
 or burning in a kiln, and used for building, pav-
 ing, etc.: traditionally, in the U.S., a rectangle
 2 1 / 4 × 3 3 / 4 × 8 inches (5.7 × 9.5 × 20.3 cm),
 red, brown, or yellow in color.
2. such blocks collectively.
3. the material of which such blocks are made.
4. any block or bar having a similar size and
 shape: a gold brick; an ice-cream brick.
5. the length of a brick as a measure of thick-
 ness, as of a wall: one and a half bricks thick.
6. Informal . an admirably good or generous
 person.

Origin:

1400–50; late Middle English brike < Middle Dutch
 bricke; akin to break
 *

Ashtray Stack

2007, Stockholm, Sweden
Duration: 10 minutes
Ashtrays

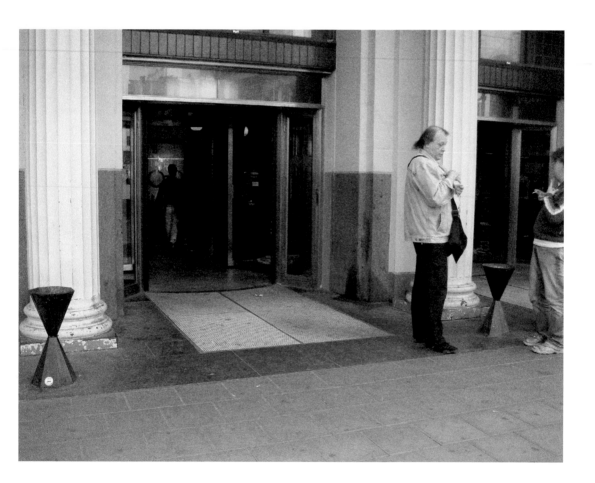

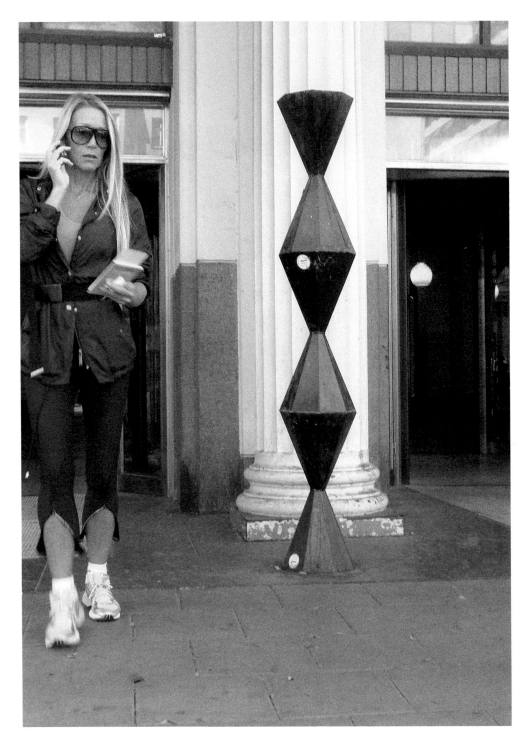

Rubbish Bin Stack

2009, Malmö, Sweden
Duration: 20 minutes
Rubbish bins
Made in a workshop for Spinneriet, School for Urban Art

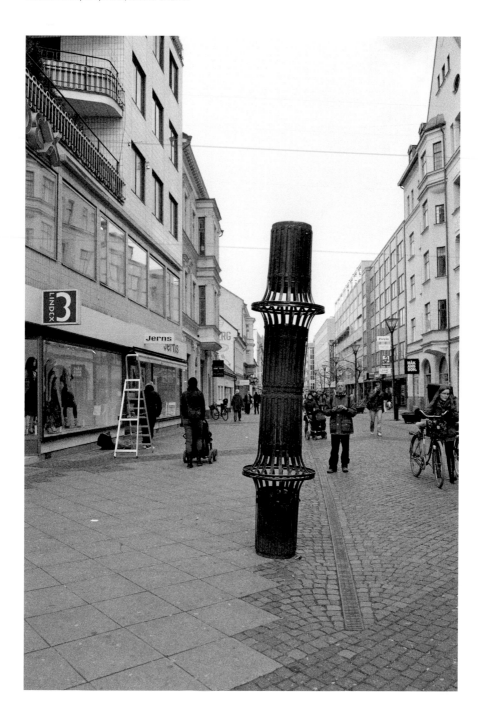

Circle Stack

2007, Prague, Czech Republic
Duration: 1 day
Concrete tubing

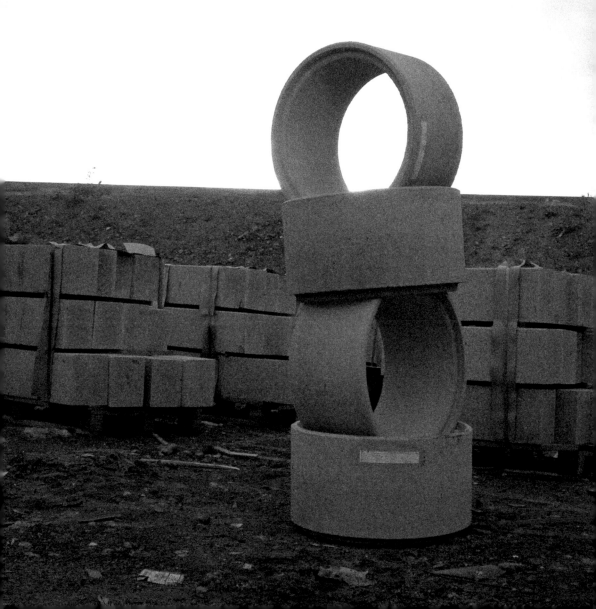

Broken Bench Prop

2009, Bourges, France
Duration: unknown
Bench
Made in workshop for ecole nationale Supérieure d'art de Bourges
A concrete bench is lifted dropped and broken, the two pieces are propped vertically.

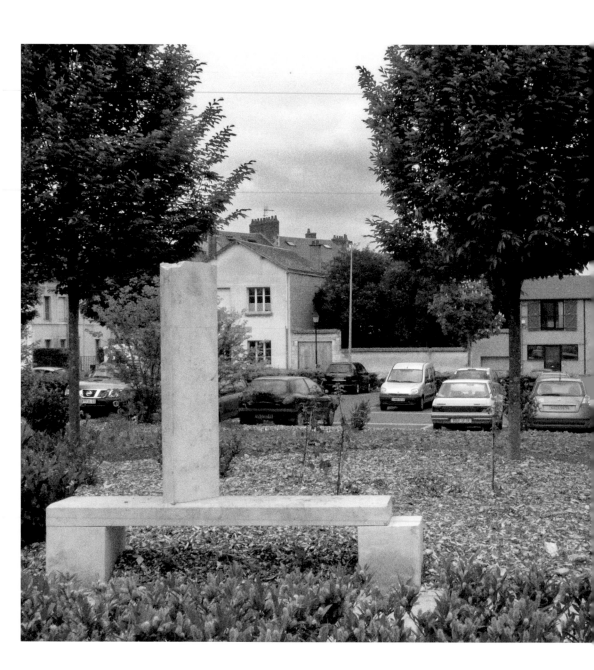

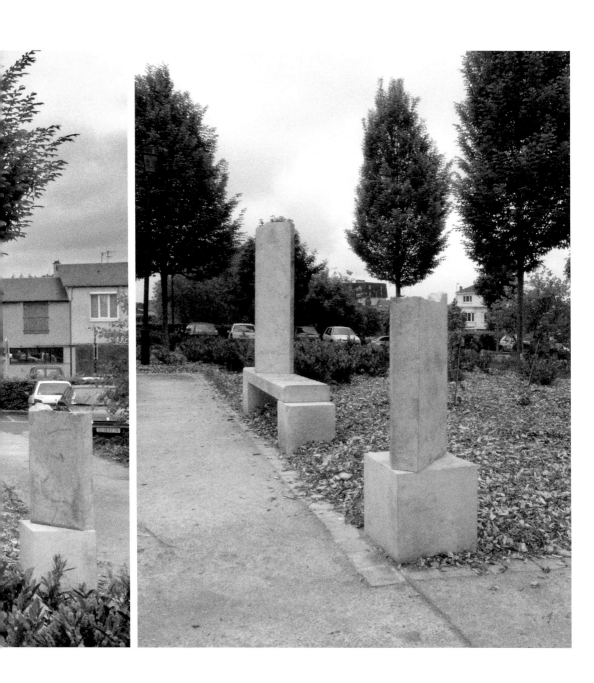

Barricade Lift

2011, Dubai, UAE
Duration: 5 days
Barricades

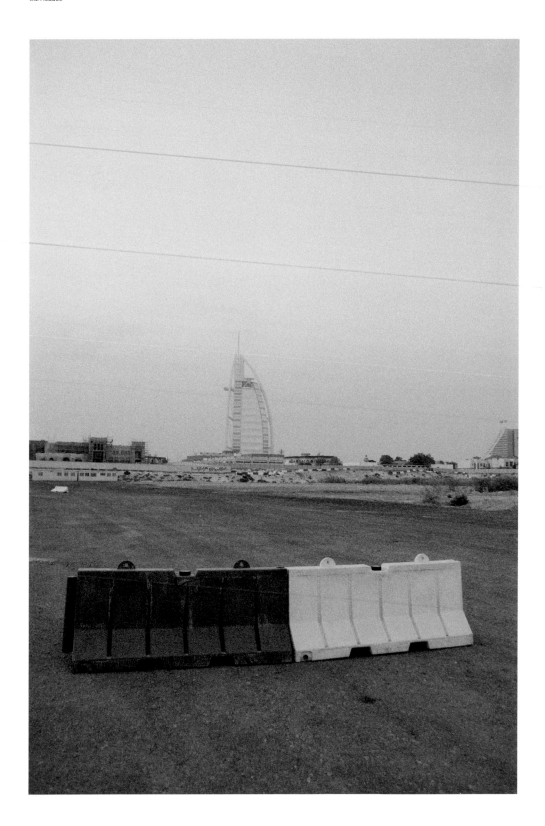

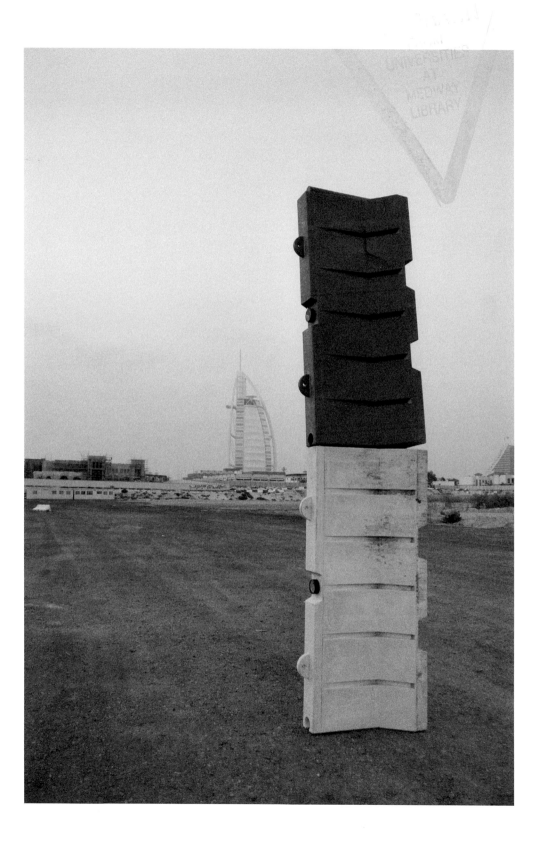

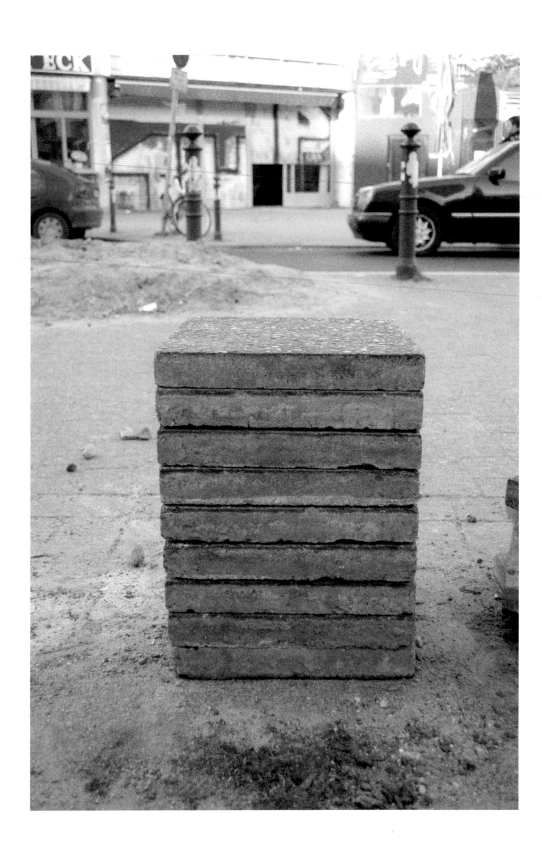

2011, Berlin, Germany
Duration: 39 minutes
Paving stones, rocks

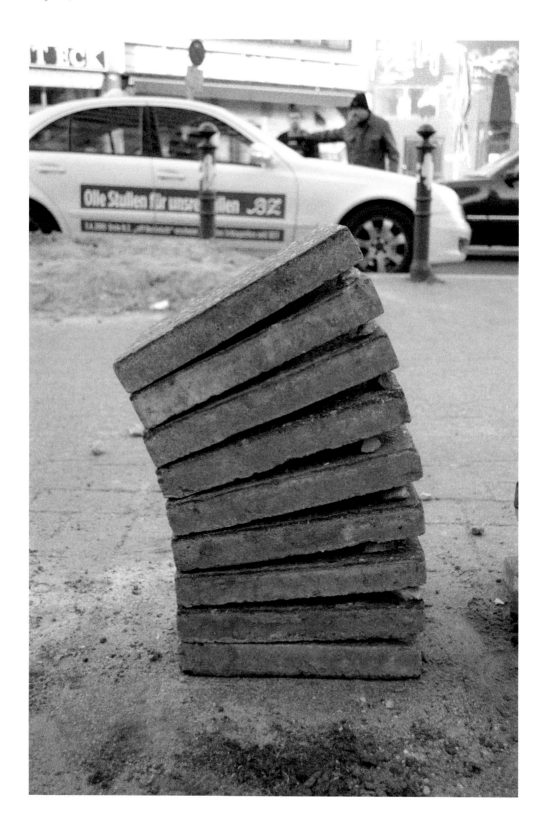

Brick Stack

2007, Berlin, Germany
Duration: 25 hours
Paving bricks

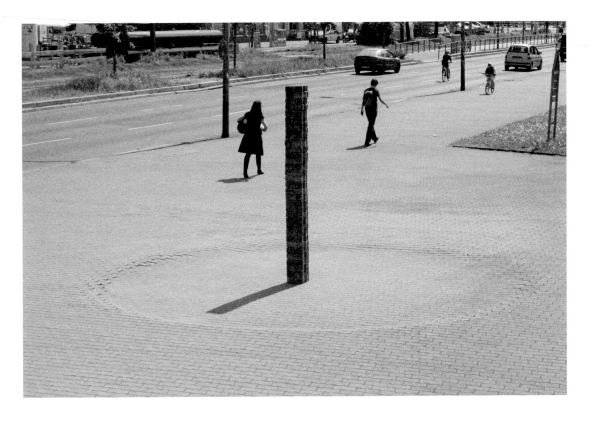

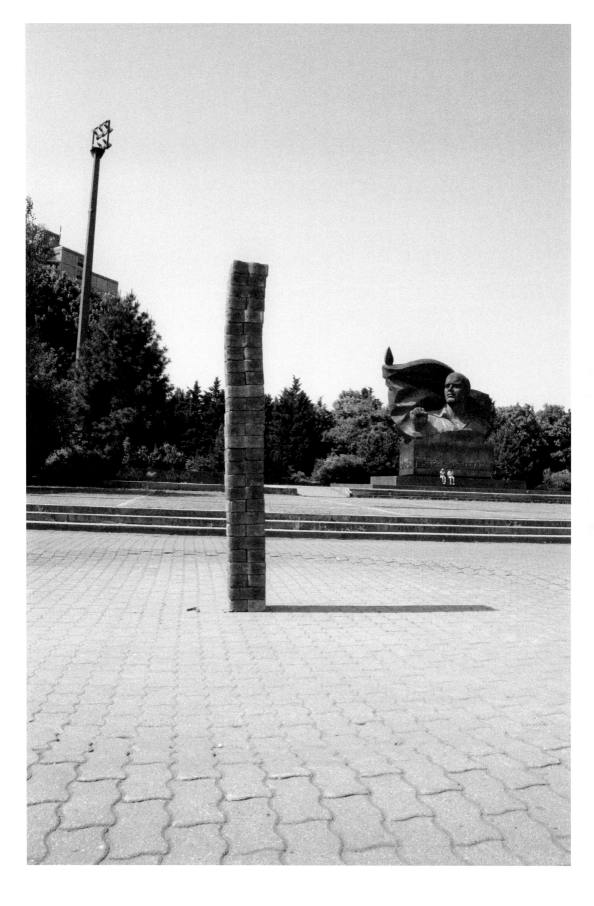

3 Cart Stack

2009, Atlanta, USA
Duration: 2 seconds
Shopping carts

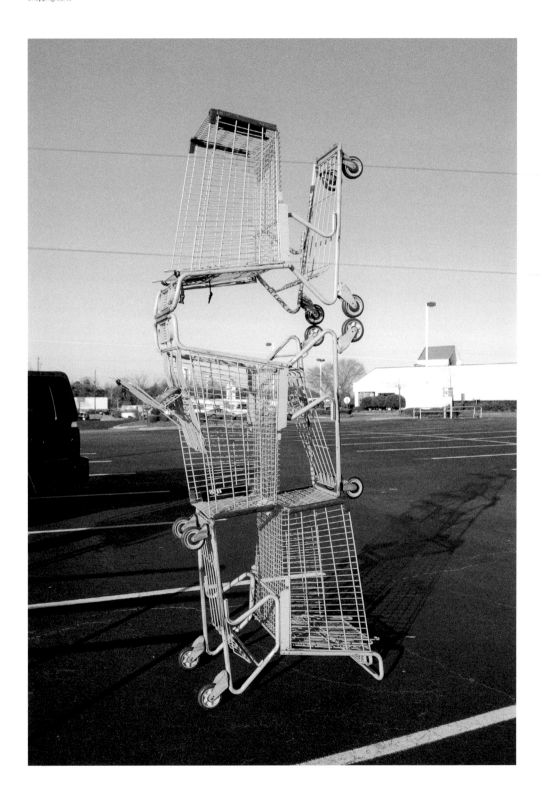

2 Cart Stack

2009, Atlanta, USA
Duration: 6 minutes
Shopping carts

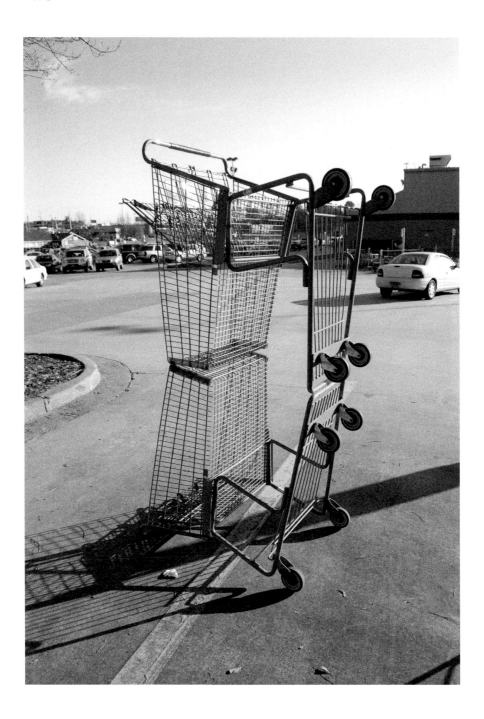

Bench Shift

2007, Stockholm, Sweden
Duration: unknown
Public benches

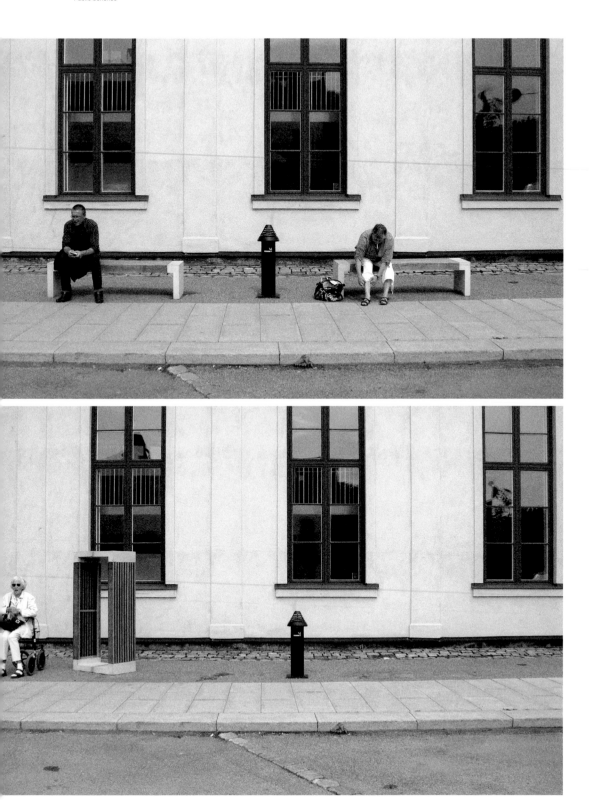

Bench Lift

2010, Roskilde, Denmark
Duration: 6 hours
Benches, tubes

next spread
(28–29)

Bench Lift II

2009, Stavanger, Norway
Duration: 4 hours
Bench, bus shelter
Made in workshop for Nuart 2009

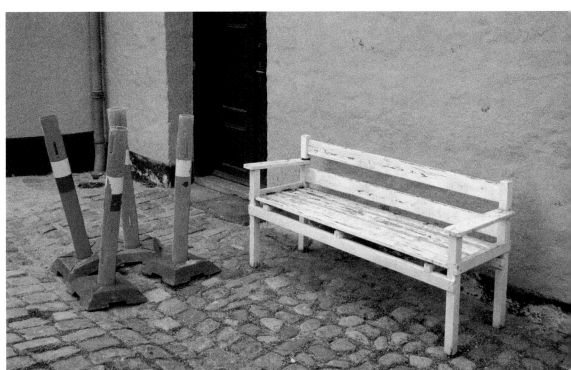

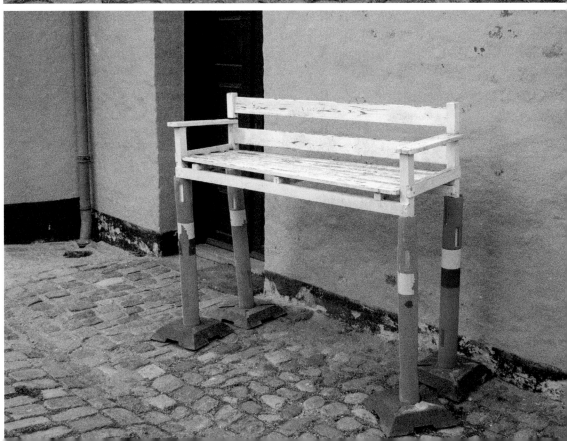

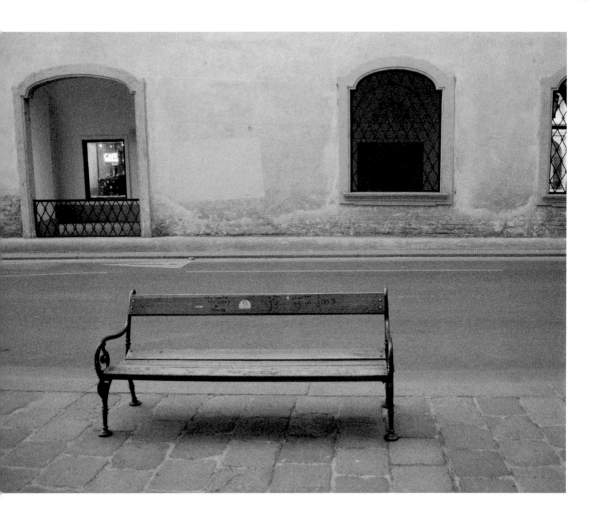

2010, Vienna, Austria
Duration: 2 minutes
Bench, fence
Thanks to Sydney Ogidan

Cart Wedge

2009, Bourges, France
Duration: 6 hours
Shopping cart
Made in a workshop for Ecole Nationale Supérieure d'Art de Bourges

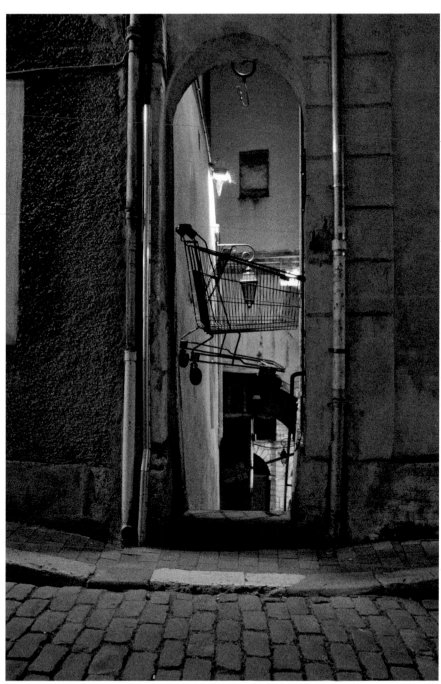

2009, Bourges, France
Duration: 6 hours
Traffic sign
Made in a workshop for Ecole Nationale Supérieure d'Art de Bourges

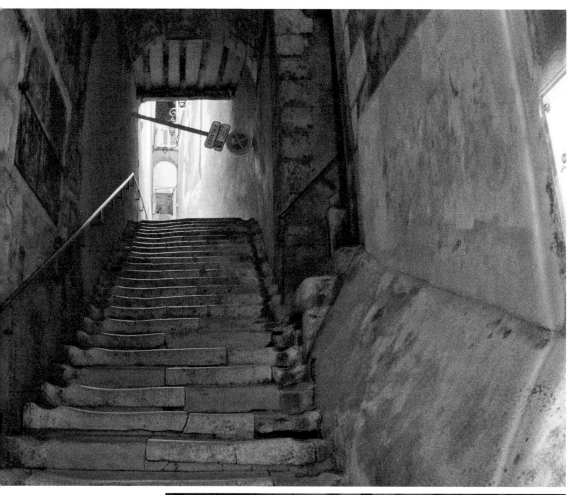

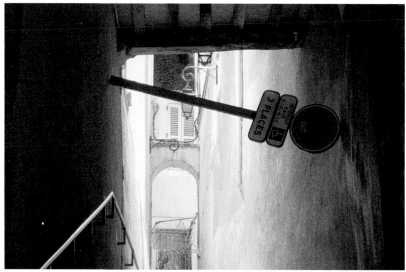

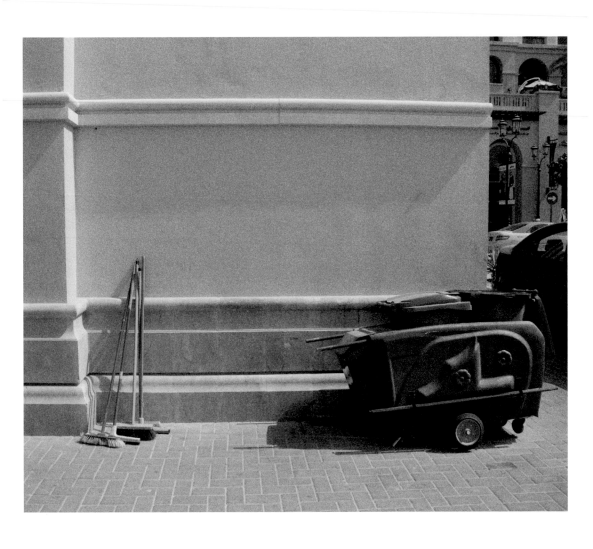

Broom Wedge Stack

2011, Dubai, UAE
Duration: 10 minutes
Brooms

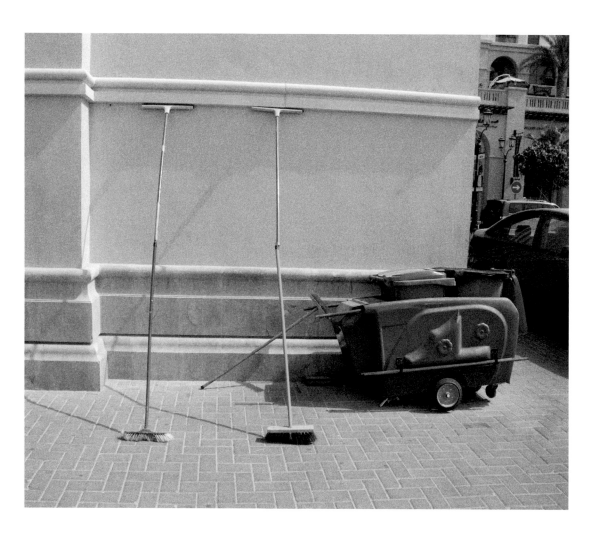

Stick Brick Wedge Stack (Support System)

2011, Dubai, UAE
Duration: 10 days
Wood, bricks, air conditioning

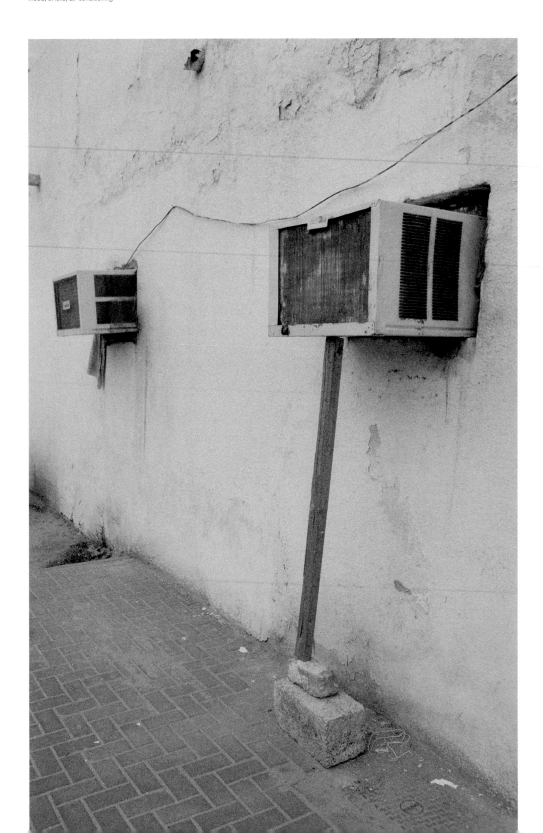

2005, Panajachel, Guatemala
Duration: unknown
Rocks, window cage

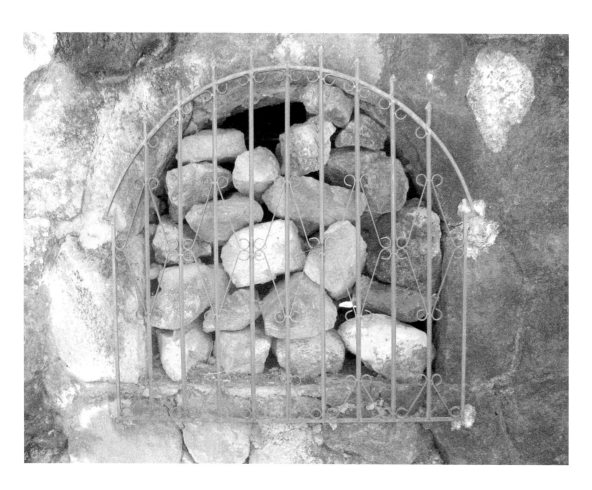

Bollard Wedge (X)

2009, Stavanger, Norway
Duration: 30 minutes
Plastic bollards, entryway

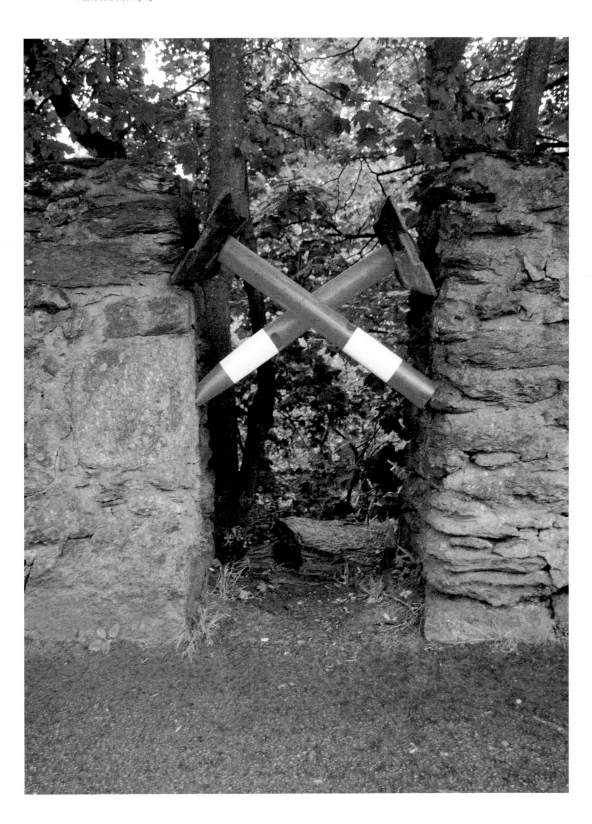

Fence Move

2009, Stavanger, Norway
Duration: 30 minutes
Car, barricades

Bricks Stack II (Wall)

2009, Bourges, France
Duration: unknown
Cars, bricks
Made in workshop for Ecole Nationale Supérieure d'Art de Bourges

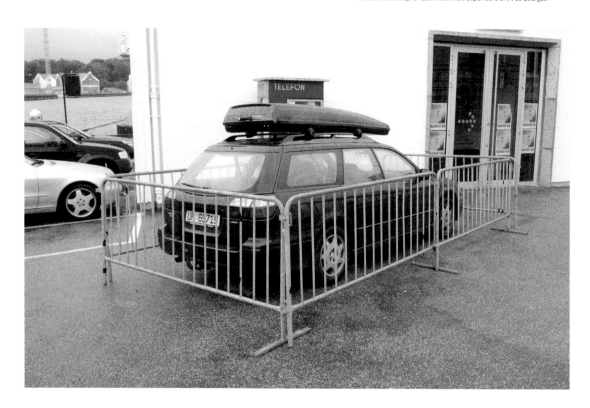

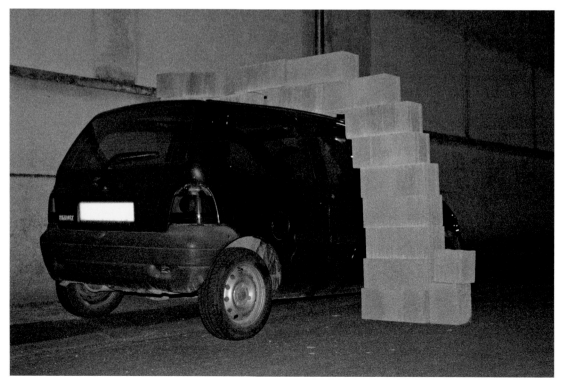

Pavement Move (Delete)

2005, New York, USA
Duration: 6 years and counting
Tree
A portion of the sidewalk was removed from around the tree.

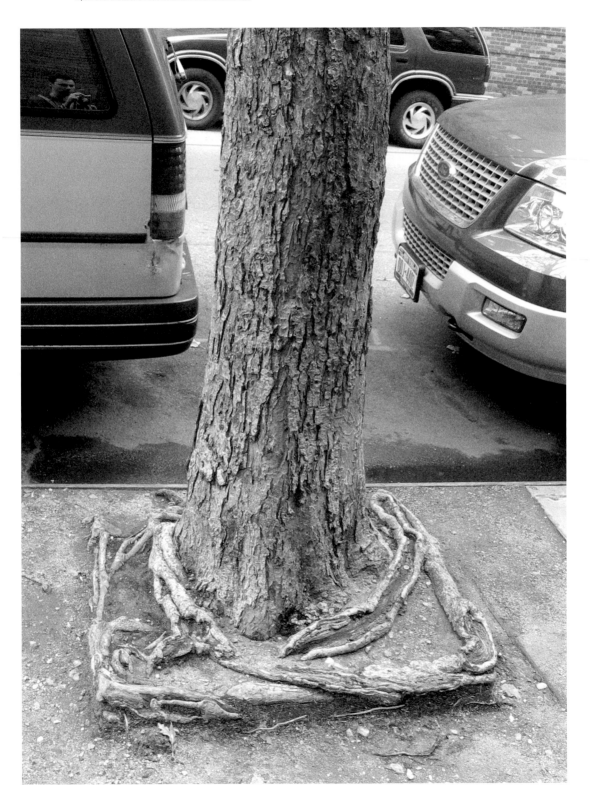

Curb Lift II (Pyramid)

2010, Seoul, South Korea
Duration: 2 days
Curbs

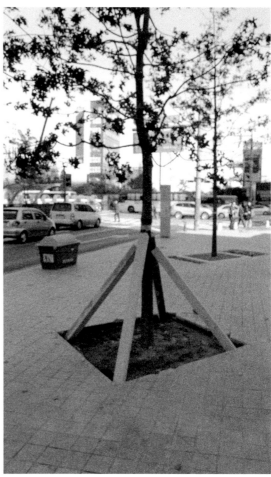

Brick Hang

2011, Dubai, UAE
Duration: 2 seconds
Bricks, caution, tape rope

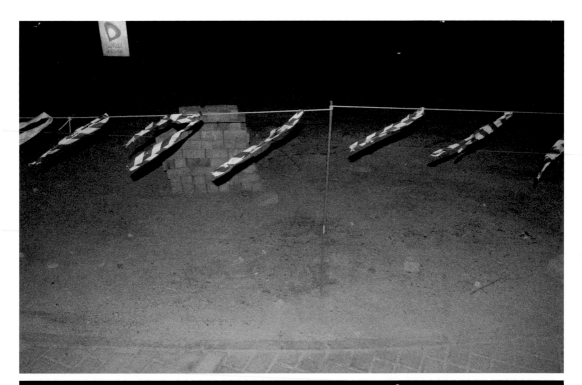

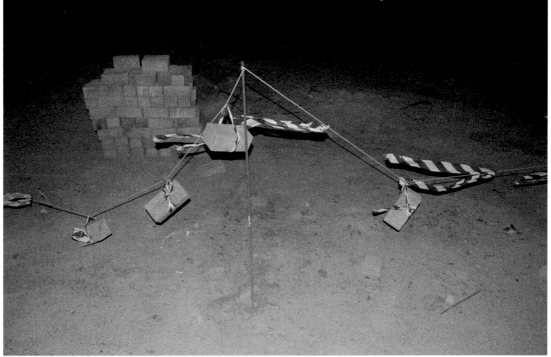

Bike Hang

2010, Bergen, Norway
Duration: 5 hours
Bike, metal pole

next spread Bike Hang II (Perfect Throw III) 43
(44–45)
2010, Essen, Germany
Duration: 2 days
Bike, lantern

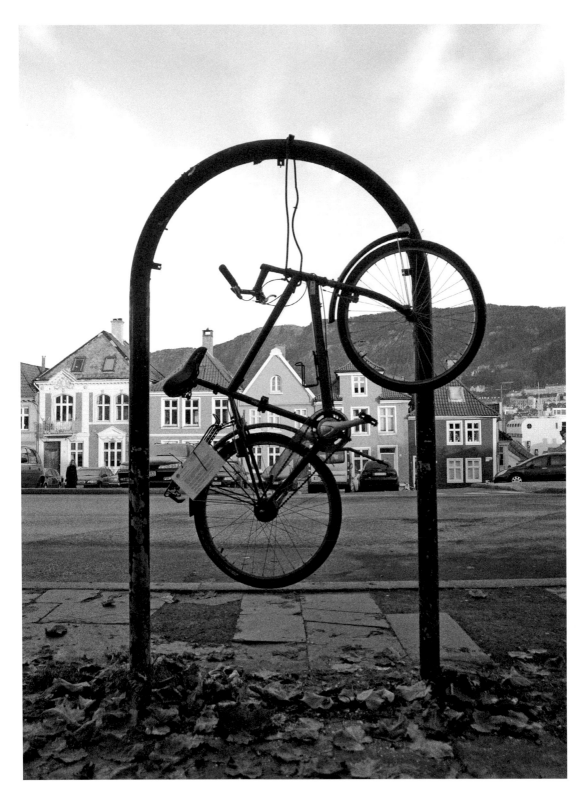

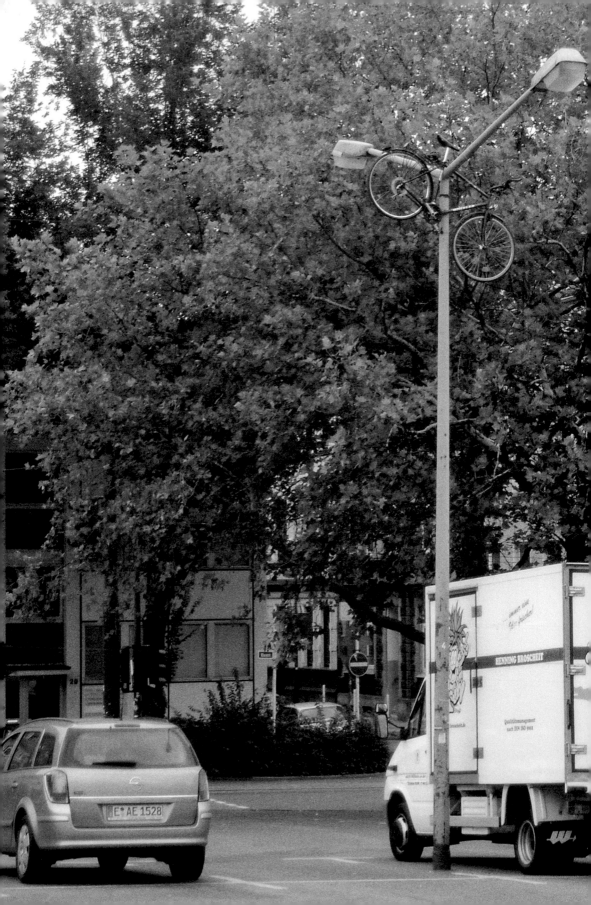

Cart Connect & Hang (Abelard and Heloise)

2008, Amsterdam, Netherlands
Shopping carts, bridge
Photo on page 48–49 by Terry Vreeburg

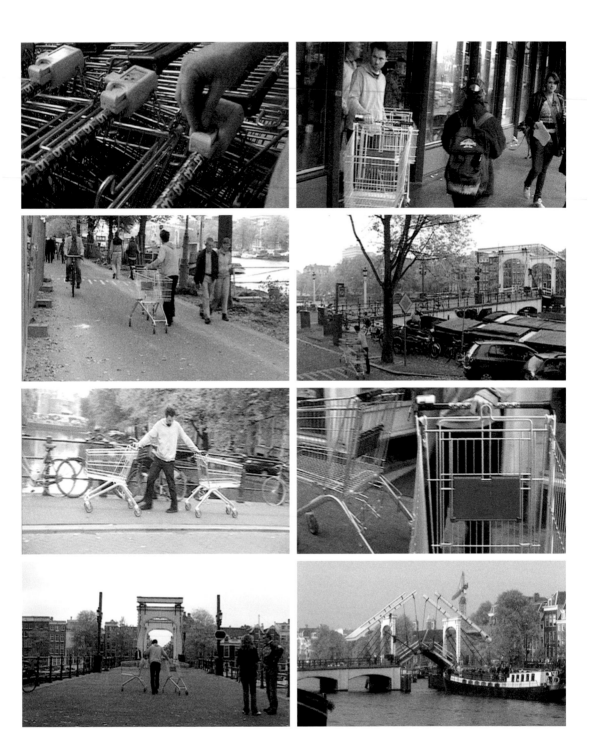

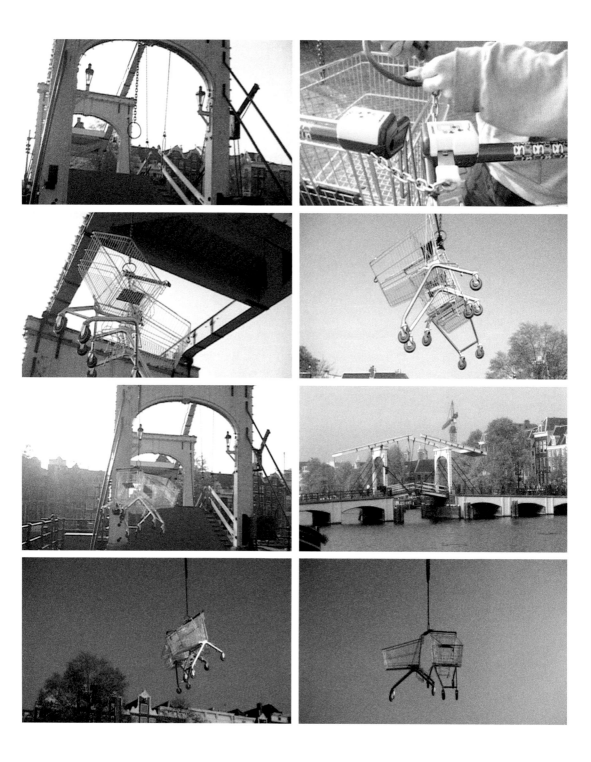

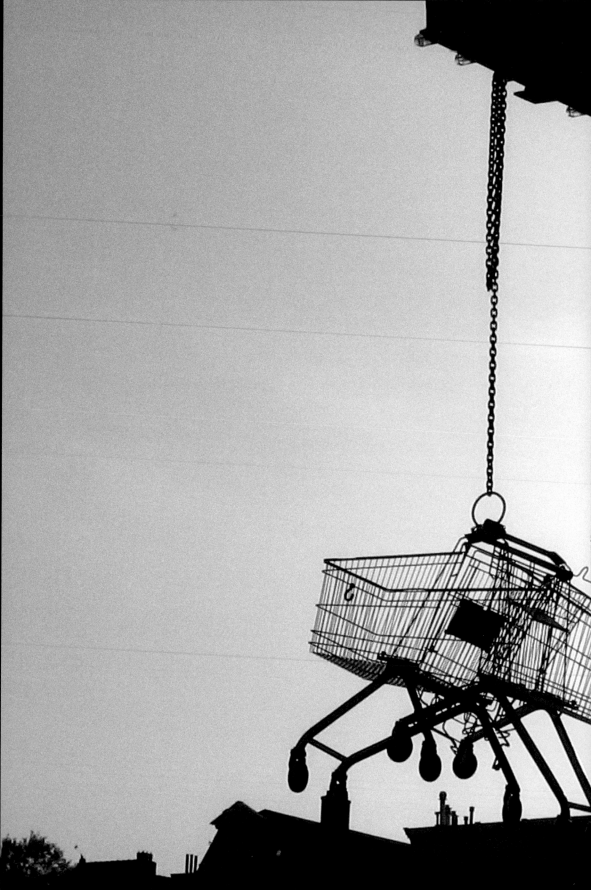

Balloon Wedge (Spinning)

2010, Manchester, U.K.
Duration: 5 minutes
Balloons, escalators

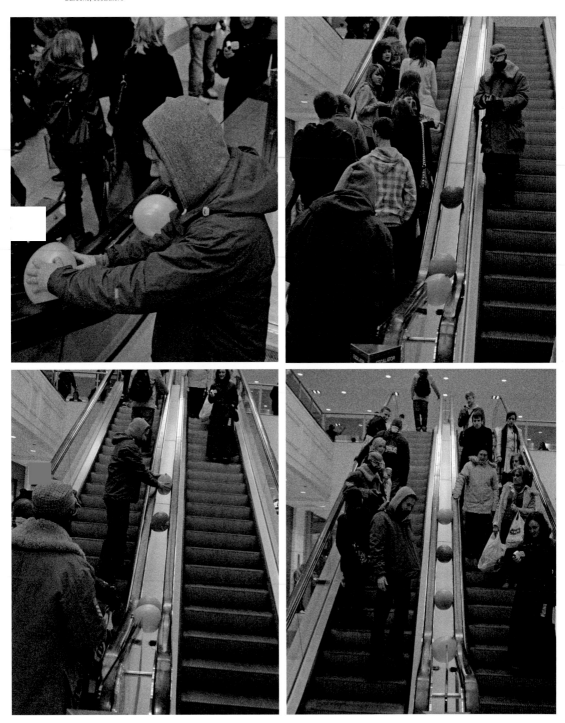

Balloons are wedged between two escalators. One escalator goes up and one goes down.
The balloons are momentarily spinning in place.

Booth Fill (La Somme de L'Oxygéne Dans une Cabine Téléphonique)

2008, Paris, France
Duration: 4 hours
Balloons filled with Brad Downey's CO₂

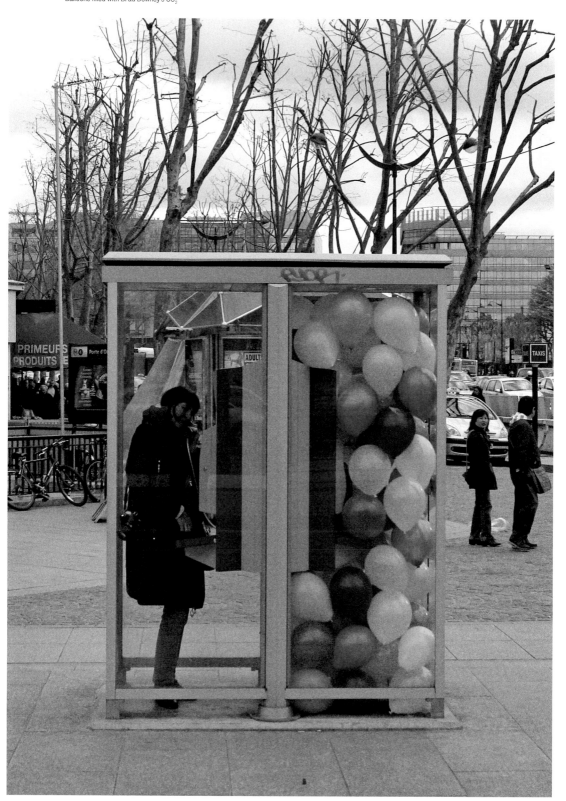

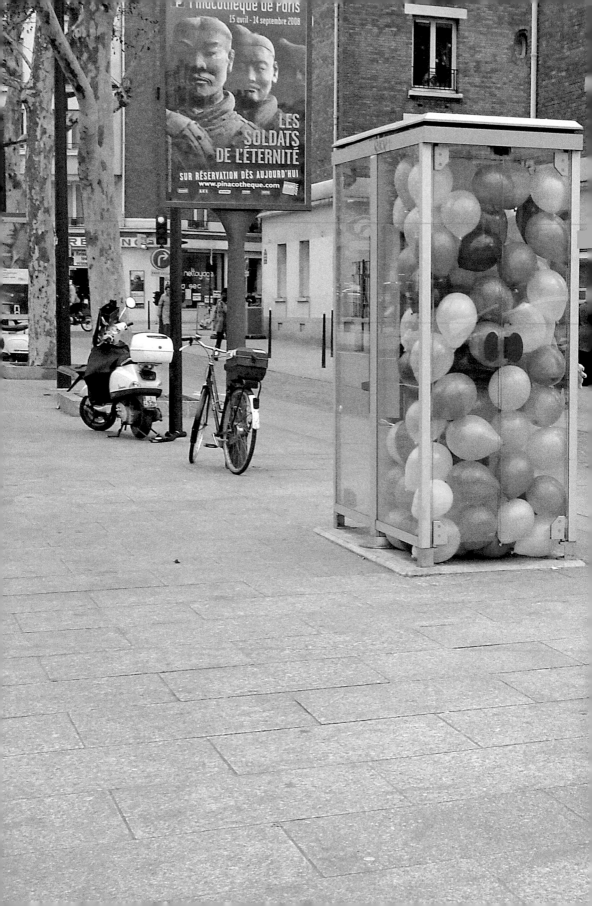

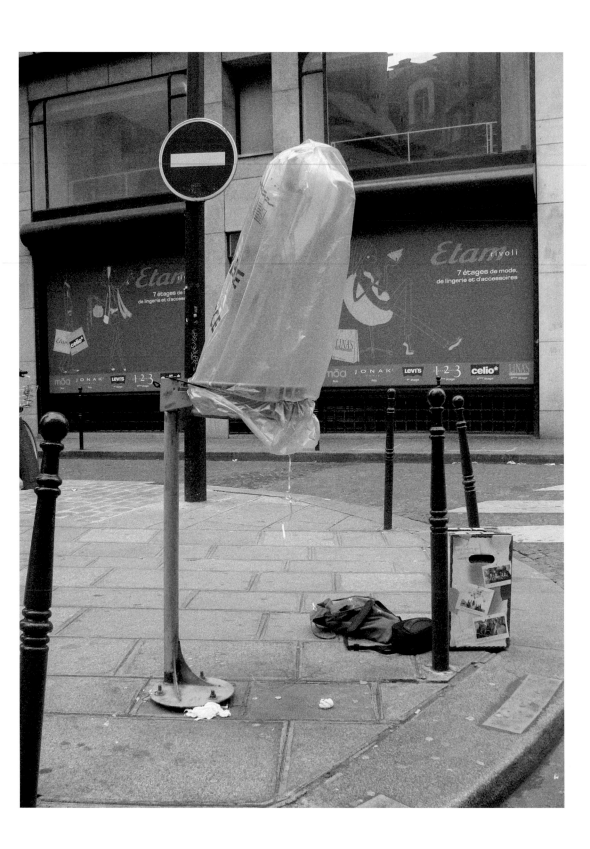

Bag Lift (Helium Poubelle)

2008, Paris, France
Duration: varied from seconds to hours
Helium balloons, rubbish bin, plastic bags

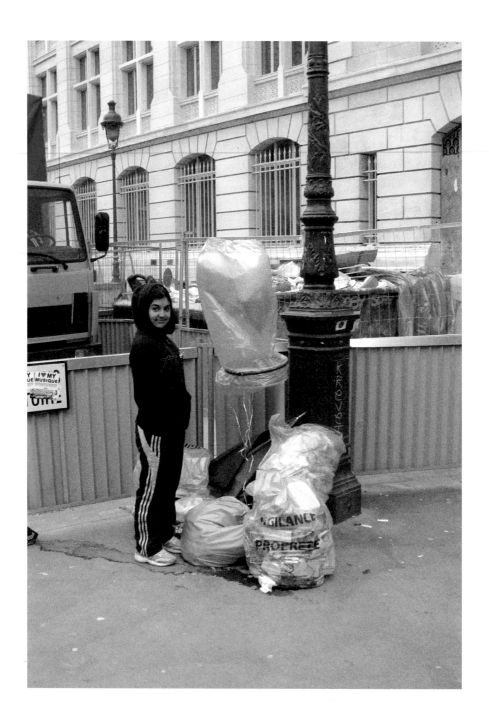

Walking around Paris and placing helium balloons in the public garbage bins.
The Parisians are afraid of terrorists just like inhabitants of every other
Western city. So, they have replaced their traditional trash cans with these
fancy new green ones. These are cool because all the garbage is exposed.
The best part of this project was watching the kids take the balloons.

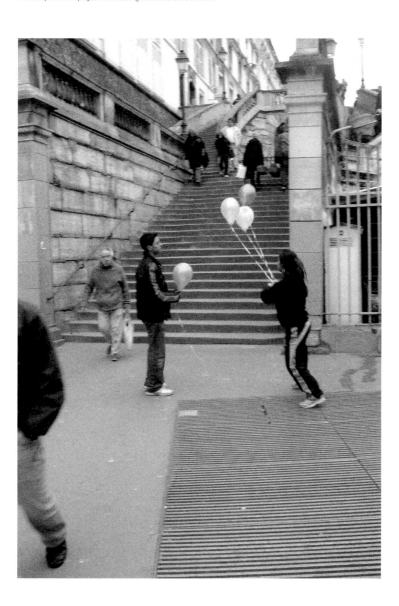

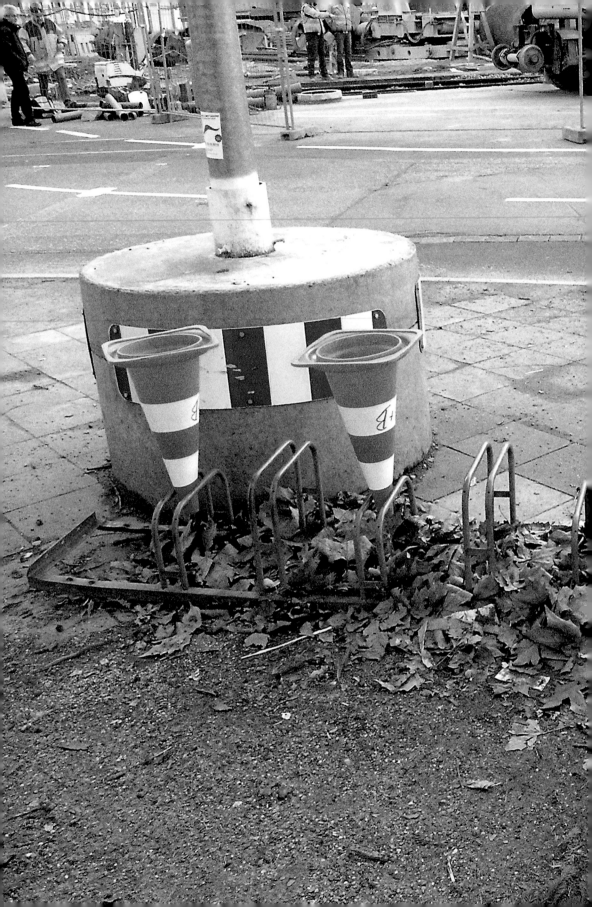

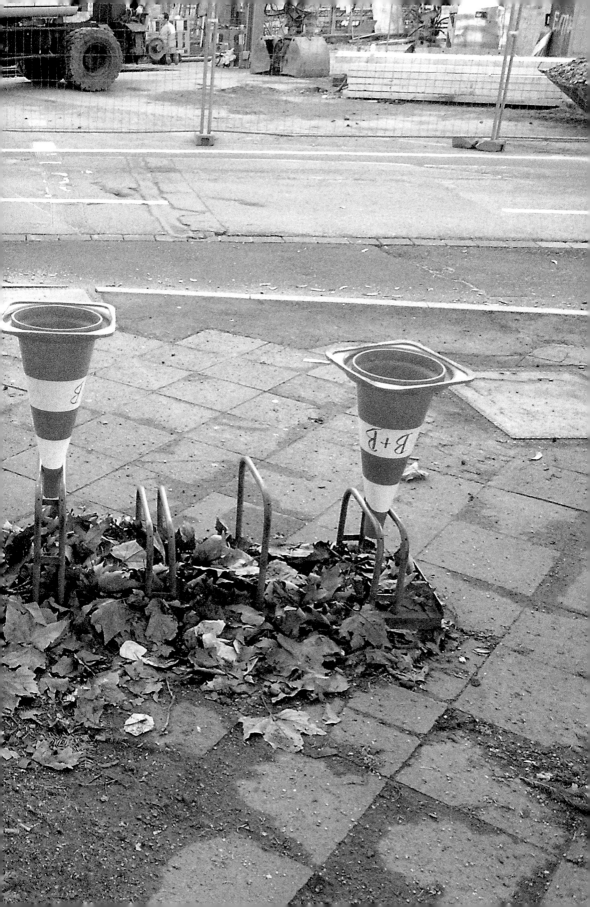

Dottlo Wedge

2010, Vienna, Austria
Duration: 2 hours
Plastic bottles

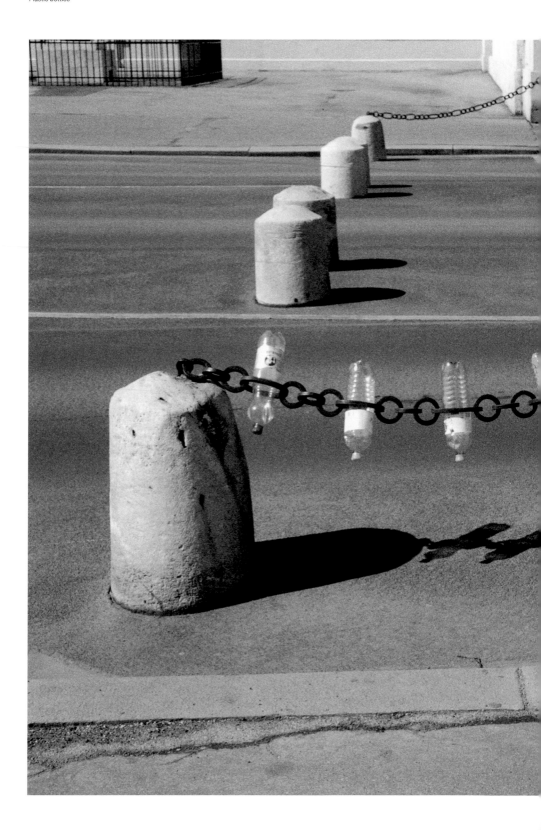

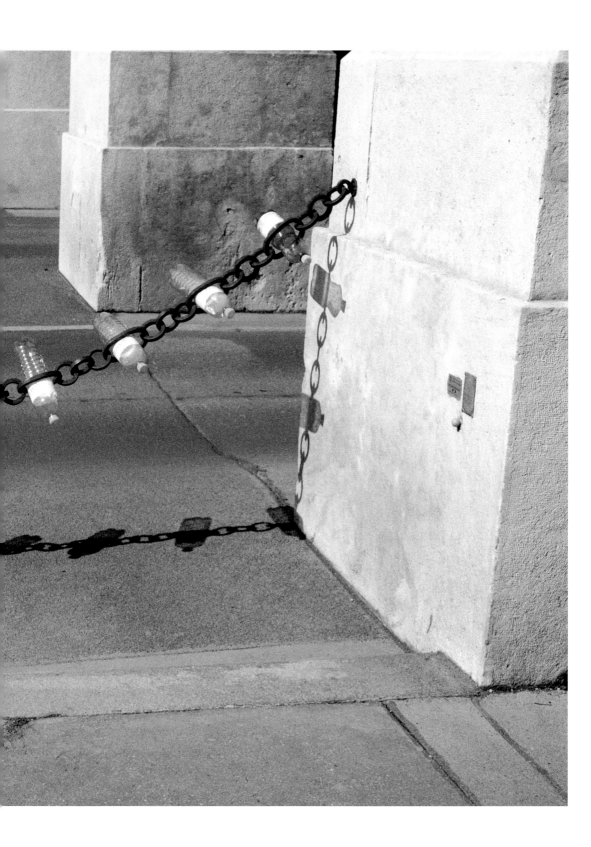

Bottle Tie (Pissing)

2009, Stavanger, Norway
Duration: 10 seconds
Plastic bottle, tape, water, sculpture by Antony Gormley
Made in a workshop for Nuart, photo by John Paul Cunningham

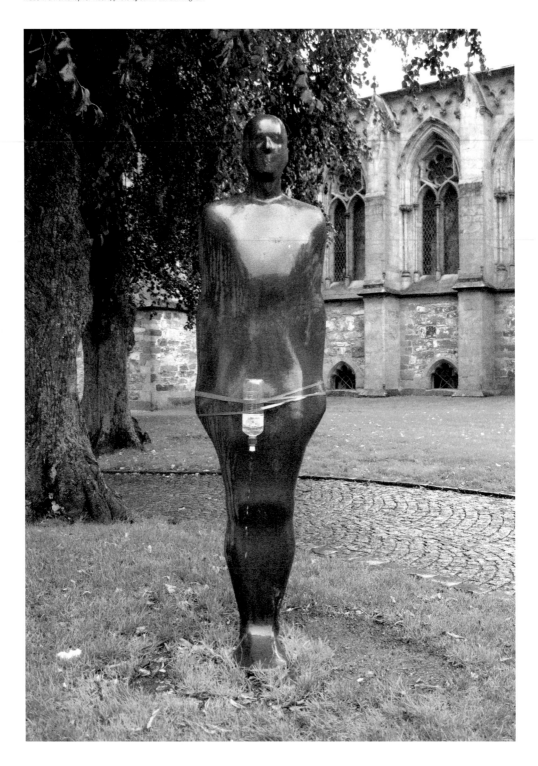

Bollard Tie (Dick)

2009, Stavanger, Norway
Duration: 2 hours
Tree, wire, plastic bollard
Made in a workshop for Nuart

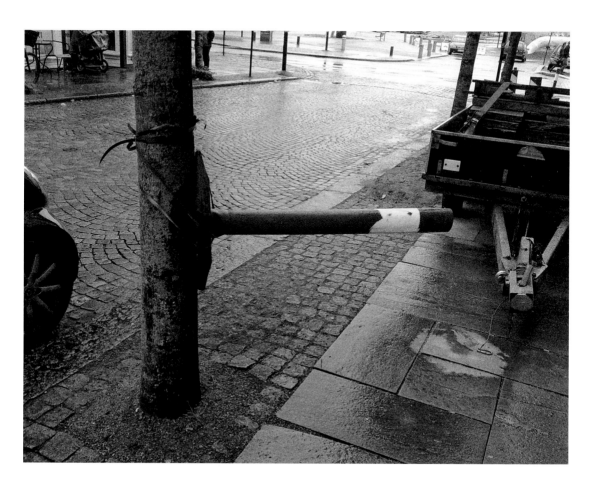

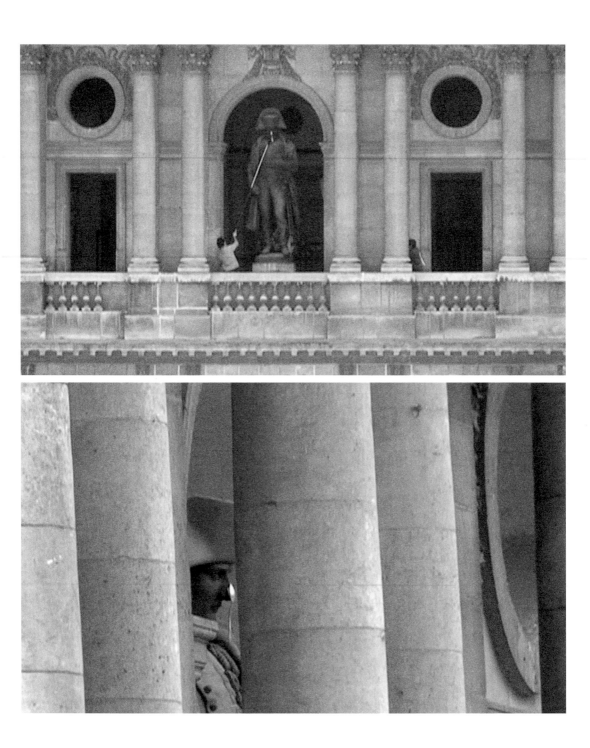

Spoon Stick (Dedicated to Sarkozy)

2009, Paris, France
Duration: unknown
Napoleon monument, bubble gum, spoon, extension
Digital videostills, special thanks Jerome Fino

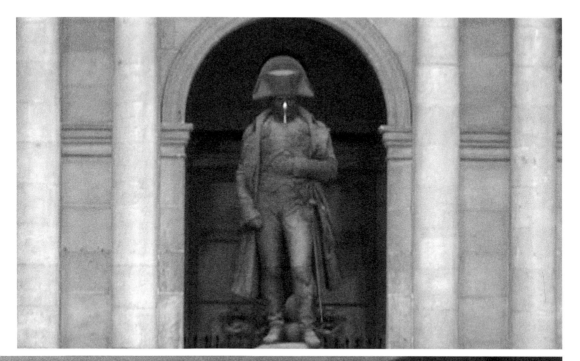

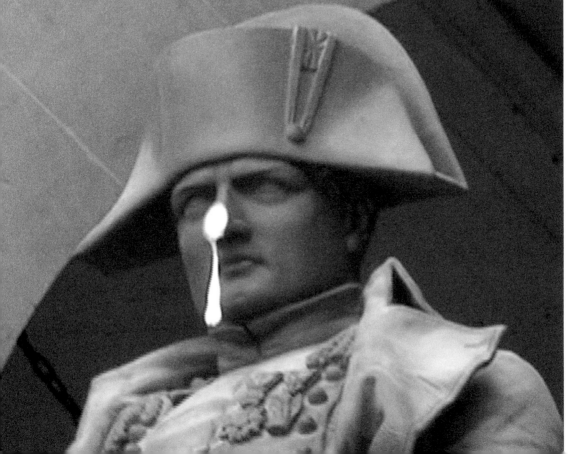

Gum Stick (Bubble)

2009, Stavanger, Norway
Duration: 4 minutes
Bubble gum, public sculpture, cigarette pack
Made in a workshop for Nuart 2009

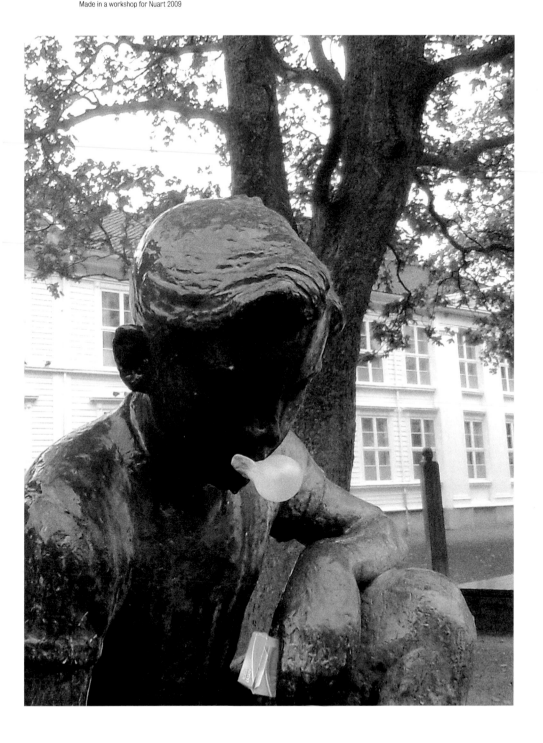

2010, Berlin, Germany
Duration: 2 months and counting
Cable straps, public sculpture

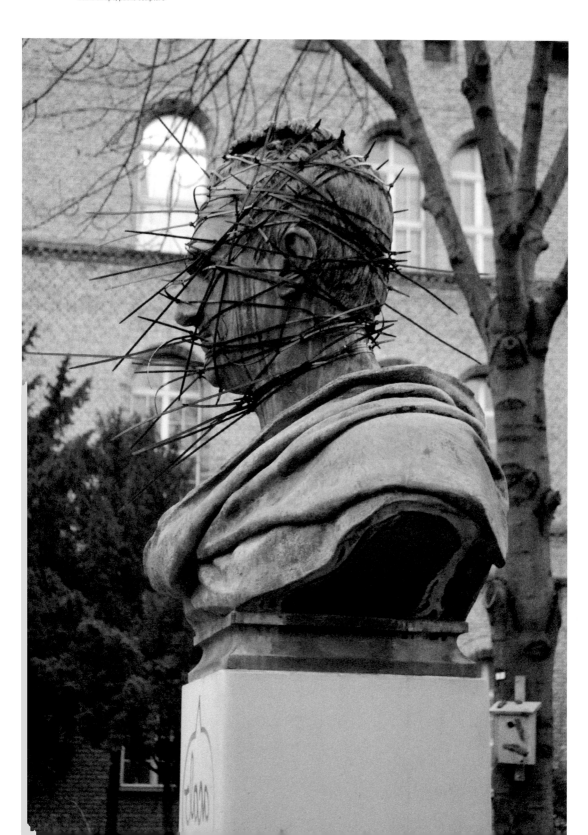

Cigarette Prop (:))

2011, Dubai, UAE
Duration: 15 minutes
Cigarettes, ashtray
Dedicated to John Paul Cunningham

Chalk Mark (Hopscotch)

2010, Berlin, Germany
Duration: 15 minutes
Chalk
Dedicated to Simon Becker

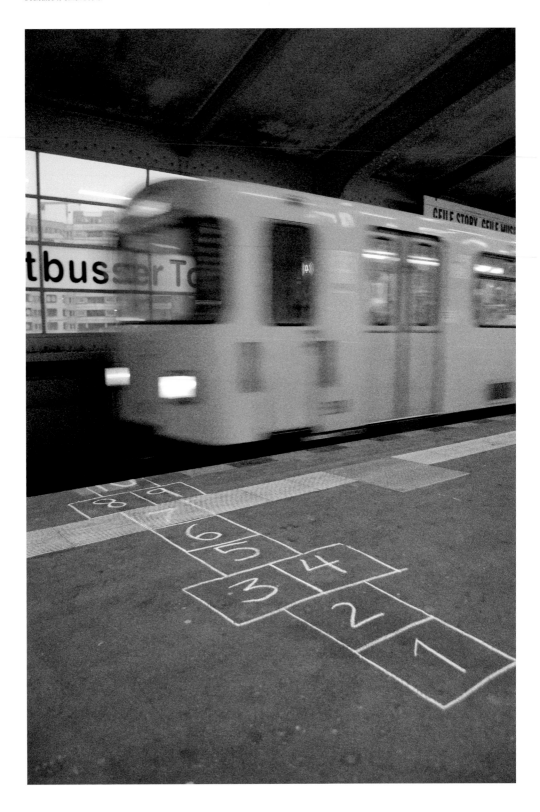

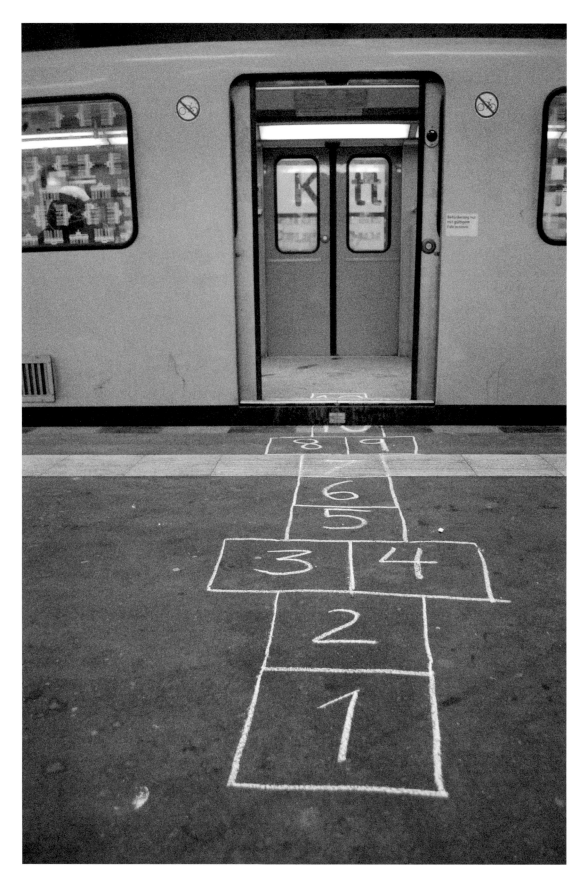

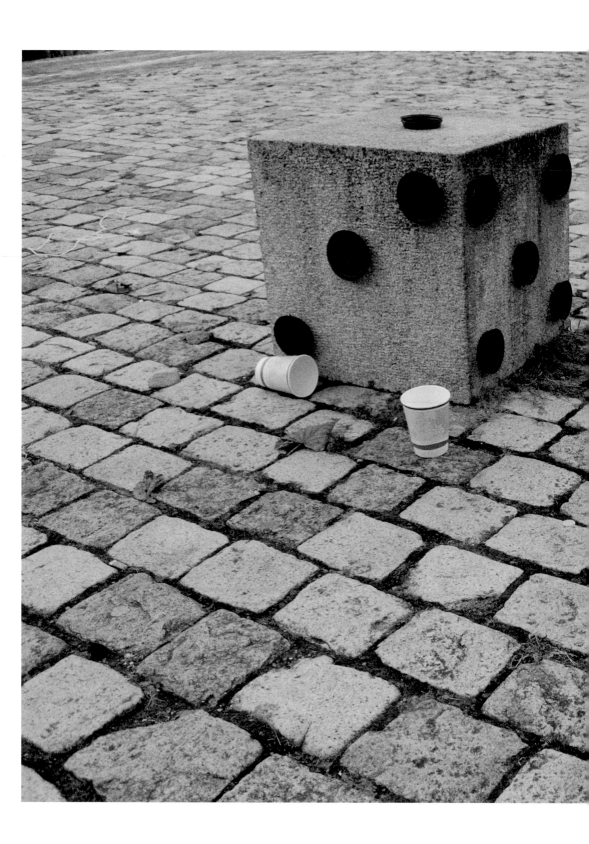

Coffee Cup Lid Stick (Dice)

2007, Bergen, Norway
Duration: 2 hours
Coffee cup lids, concrete bollard
Made in workshop for Sunnhordland Folkehogskule

74 Bollard Move

2011, Dubai, UAE
Duration: 20 minutes
Concrete bollards

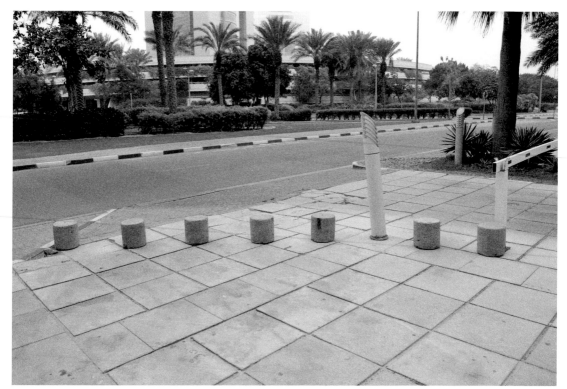

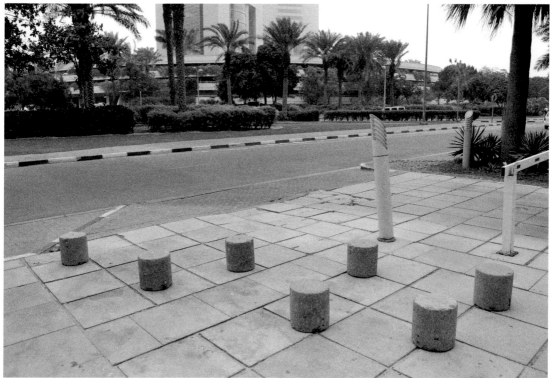

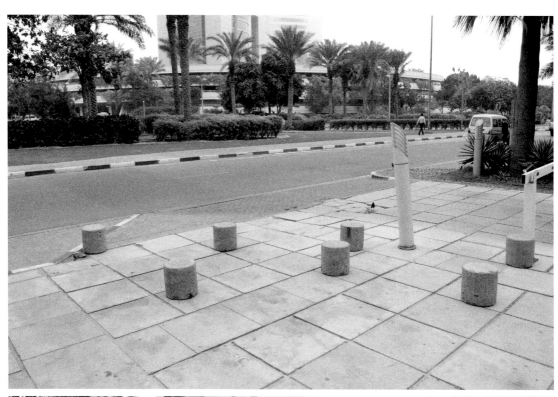

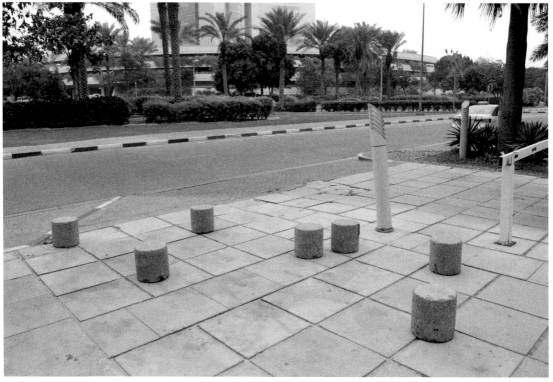

2011, Berlin, Germany
Duration: 5 minutes
Salami

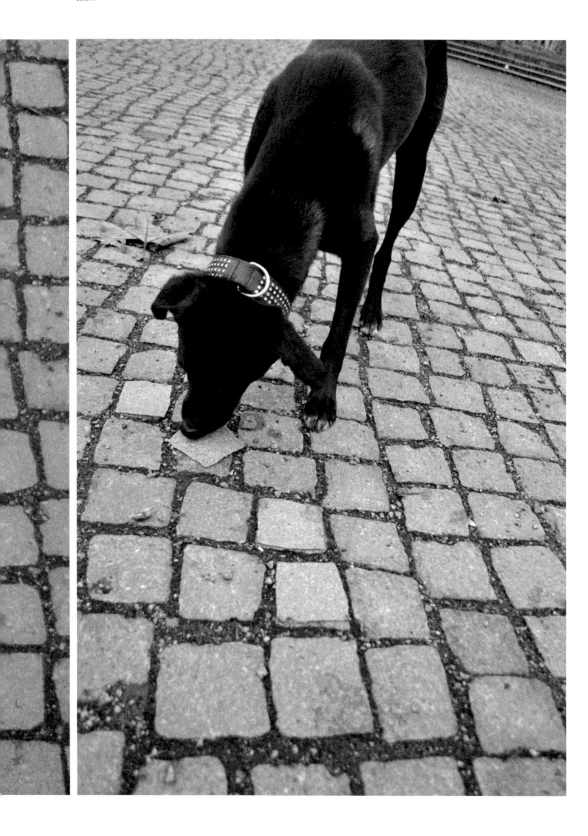

Paving Stone Shift (Swastika Street)

2010, Lisbon, Portugal
Duration: unknown
Paving Stones
Made in collaboration with Cromie Homie

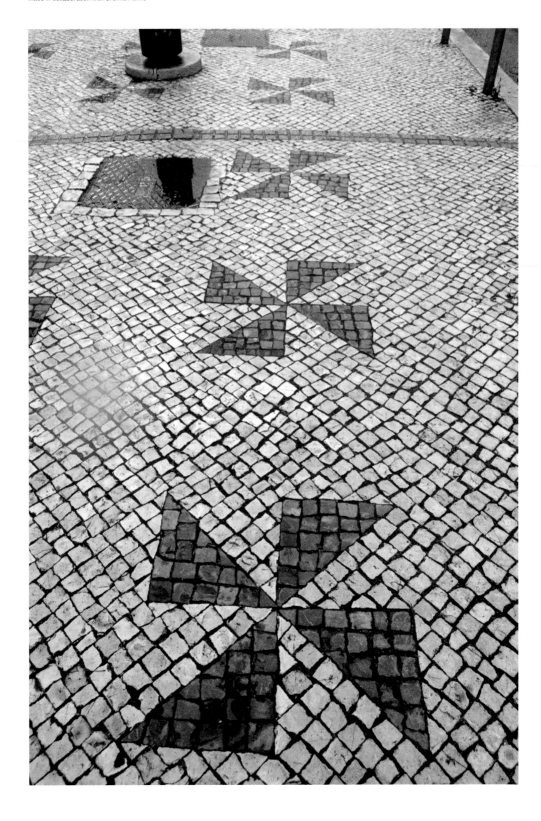

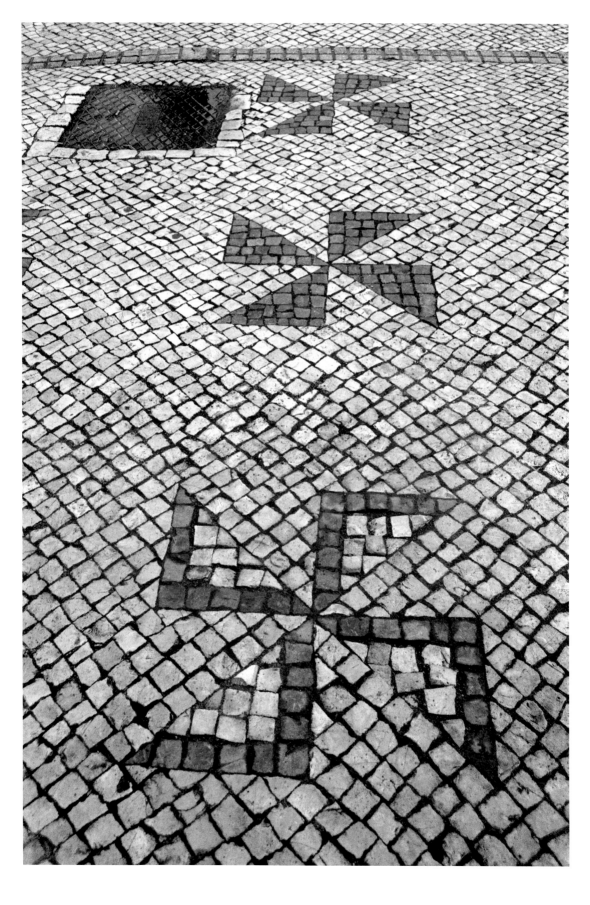

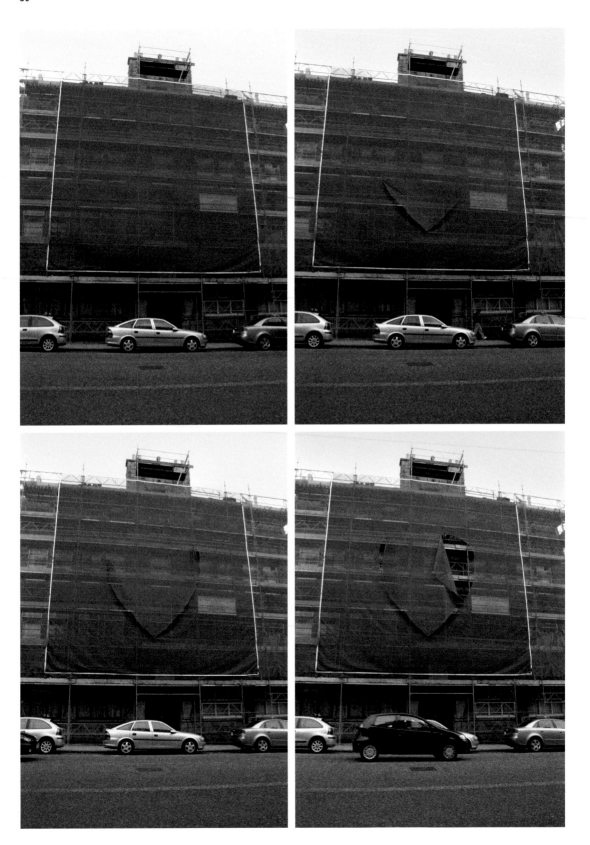

Tarp Cut (Ladder-Stick-Up)

2007, Aberdeen, Scotland
Duration: 9 days
Scissors, tarpolin
Photos by Brian Ross

next spread
(82–83)

Toilet Paper Tie (Slingshot)

2009, Malmö, Sweden
Duration: 6 hours
Toilet paper, tree stump
Dedicated to Matthias Hübner

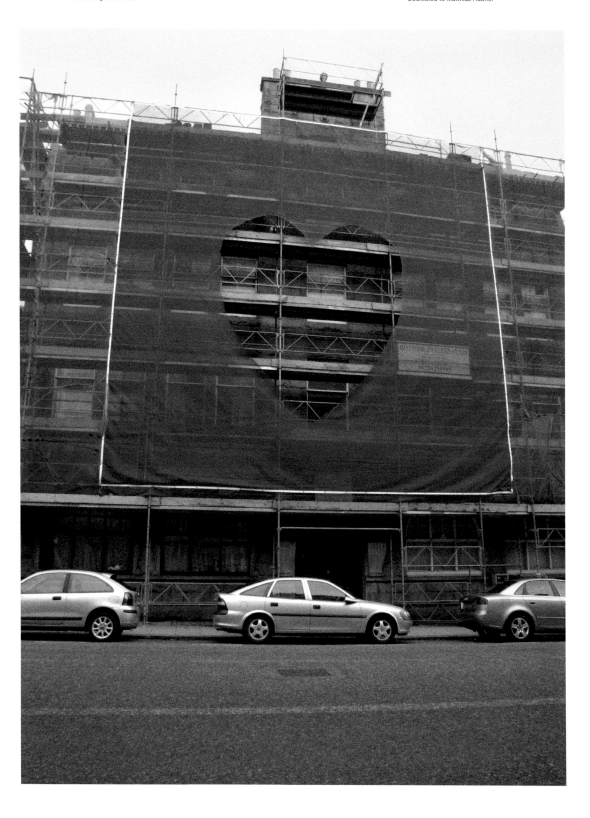

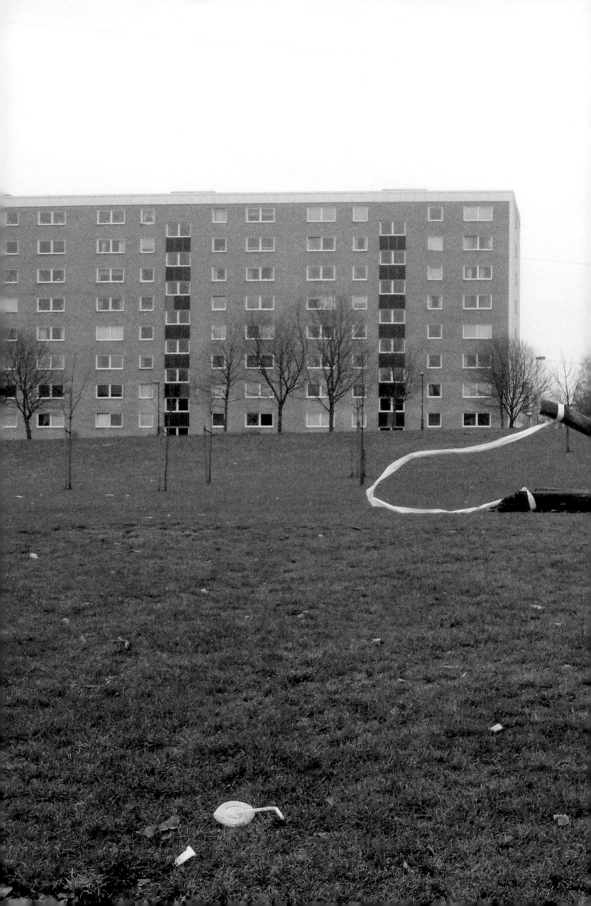

Window Smash (Just Taking the Building to its Logical Conclusion)

2008, Berlin, Germany
Duration: 2 years and counting
Deserted building, windows, rocks
Dedicated to Gordon

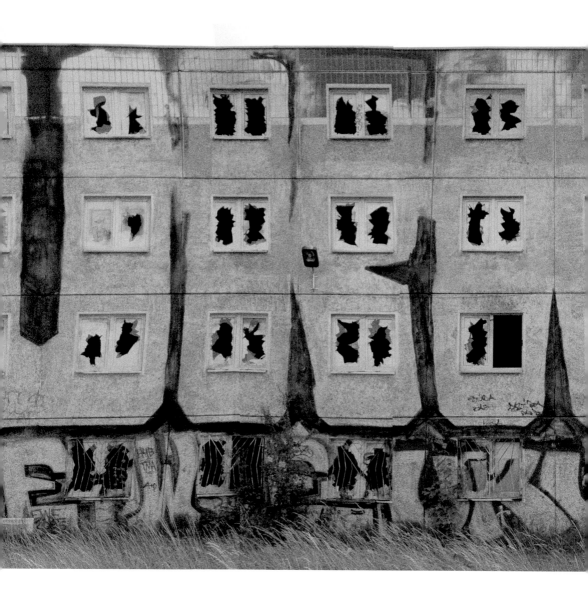

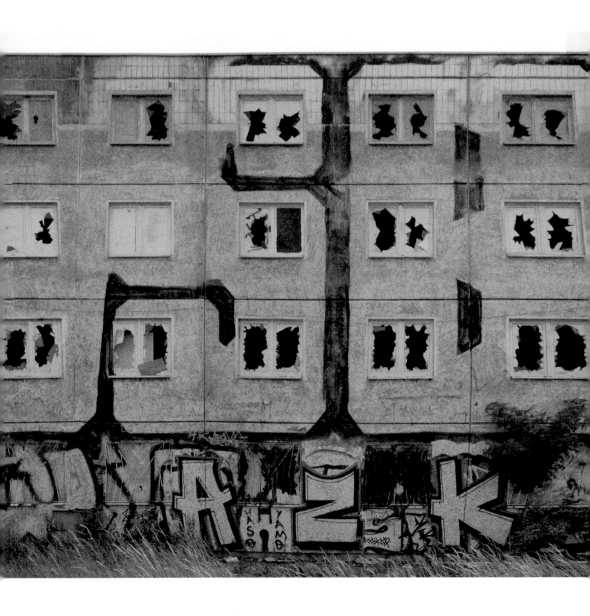

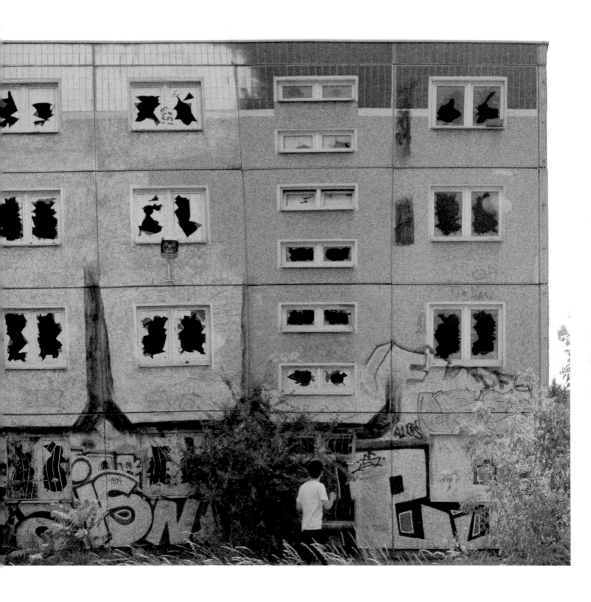

Light Smash (sHELL)

1999, Atlanta, USA
Duration: unknown
Shell sign

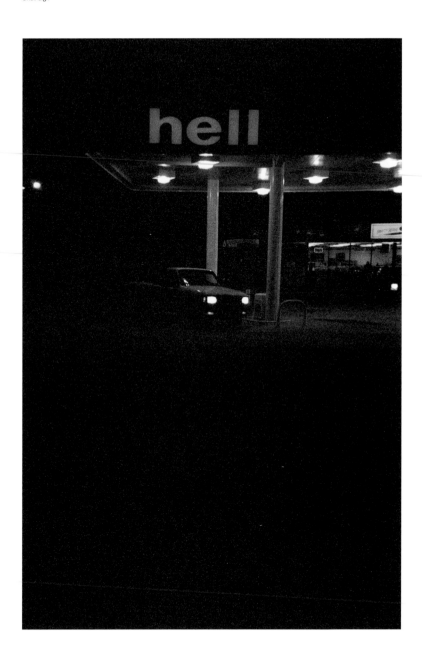

Camera Burn (CCTV Sacrifice)

2008, Berlin, Germany
Duration: 2 minutes
CCTV camera, gasoline, matches
Photo by Fahrlaessig

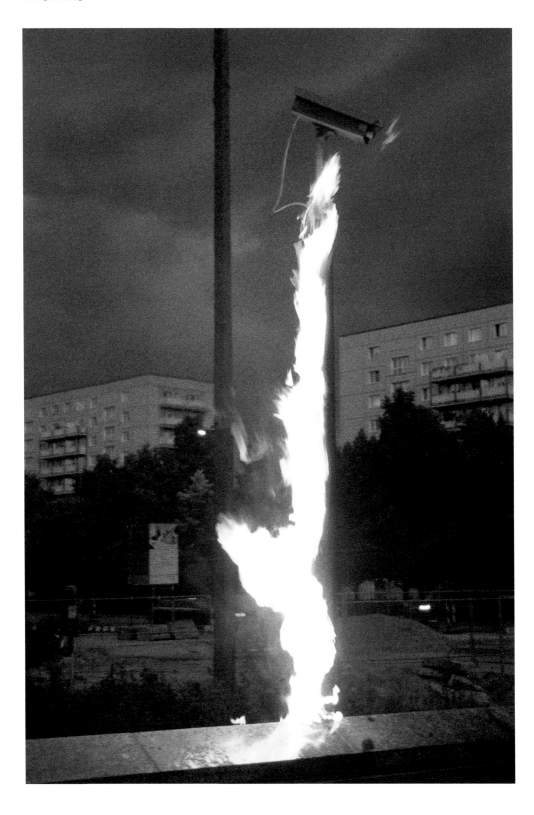

For me building or breaking is the same

Interview with Chiara Santini Parducci

An excerpt from a conversation between Chiara Santini Parducci and Brad Downey
March 24th 2011, in Kunstraum Kreuzberg/Bethanien, Berlin.

"The value of cities is measurable with the number of places they reserve for improvisation."

Siegfried Krakauer [1]

Giorgio Agamben in his Enfance et histoire[2] talks about the lack of experience in everyday life in contemporary society. You can have a very busy day, you can go to work, take the subway, read the news, meet people, watch television, go to bed, have a lot of facts in your day and have no experiences. Everything is there by accumulation, so one doesn't notice. Would you say that your interventions join in this parade of meaningless events, or that they truly impact on the daily life of the average person?

I hope my work could have the potential to inspire people to change something. This is my job, to show others that it is at least possible to change a city and participate in questioning objects.

How do you think people perceive your interventions?

Construction workers come across my work very often, and it's not a moment of artistry for them. It's only an accident that needs to be repaired. They are so used to seeing things in disarray that any small changes I make are not significant to them. They see things functionally and how they fit together in a prescribed way, and I do the same thing but use de-construction and re-arrangement to find new potential for materials.

I also think that a construction worker's accident can be much more beautiful than a conventional sculpture. I am there with them in a way, and actively participating, looking at what they're doing, for example, the way that they place the pavement stones; the way that they can remove a bollard; the way that the city is physically shifted around.

For example, among the general public, someone who works at a flower shop will look at potted plants in a different way than others and might notice any changes to them in their city. My piece, Pot see p. 149 Flip, in which I flipped over a potted plant, I imagine could have a negative impact on a florist, but seeing it could be part of a very funny day for another passer-by. Or maybe the guy who made the pots is happy to again see the bottom of the pot, because he doesn't see it very often and he is pleased with how well the bottom was made. It just depends on point of view. But I think that for another person who never looks at pots or at plants, for him, it's just invisible.

Is the intention of your work always the same, both for works which appear destructive or appear creative?

Yes. For me, building or breaking is the same.

Do you consider yourself an artist?

I used to work in a studio making large sculptures, which I then installed outside illegally. Often, when I was placing them outside, people asked what I was doing, and if I replied, "Art," then most said, "Ah, OK," and I could see they would stop thinking about the work. It seems to me that people who are not familiar with the art world would assume that they wouldn't be able to understand it. So I instead started answering people by saying: "This is something that I have to do." With this answer, I could see that people were beginning to think to themselves: "Why does he have to do this?" To them, it must be strange to see someone working outdoors in the city who is clearly not being paid.

Do you ever need the help of other people, or use tools or machines? And if you do, do you feel that this alters your work?

Sometimes I call in outside help, although I feel that may pollute the spontaneity. But if I happen to be with somebody already, it is more immediate. The more important issue for me is to get away from thinking that to make sculpture, it is necessary to have tools. Traditional sculpture has always been material-intensive. The important thing for me is to figure out how to work with physical forces such as gravity and the materials that are already at the site.
And sometimes when I use tools, the results are unexpected, and they can alter the work. For example, in the piece Pavement Squash, I had see p. 46 originally planned to make a wall painting, and had hired an industrial lift. The ground underneath the lift was squashed in by its weight. And this became the artwork for me. So in this way, the tool that I was using led to an accidental and spontaneous work, one different from the artwork I had intended. But still a spontaneous sculpture. And the wall was never painted, because the lift was too heavy for the ground underneath.

But you had been planning another work – to paint a wall?

Just because I didn't plan to make that work doesn't mean that I was not meant to make it.

So you work with what you encounter?

Yes, it's just like re-arranging objects which represent certain things, and I'm changing their definition. Composing what is already at the site, rather than bringing things in or taking things away. I think this work for me is really about re-organizing the information which is there.

What if you do something and nobody sees it?

I don't think that this is important. I feel that if I do something in the here and now physically, this will touch people directly, whether they see it or not. I don't know why, but I think all physical materials are communicating with each other in other ways. Ways that are not just tangible, or visible or audible.

Is it because it takes a space? As a material it occupies a certain amount of it? A quantity of presence?

Maybe.

[1] Siegfried Krakauer, "Rues de Berlin et d'ailleurs", Le Promeneur, Paris, 1995; trad. de l'allemand par Jean-François Boutout.
[2] Giorgio Agamben, „Enfance et histoire", Payot, 2001.

Get it and move on

A conversation between Thomas Bratzke and Brad Downey

This interview between Brad Downey and Thomas Bratzke took place on March 25th 2011, in Kunstraum Kreuzberg/Bethanien, Berlin.

What you do is sometimes hard to recognize as a work of art. I am referring specifically to your spontaneous interventions in the city. Does this fact matter to you?

It isn't important for me that people view my interventions as "works of art." It is important for me that the public reconsiders how it defines my work. People are more comfortable referring to the photograph or video that I take to capture my interventions as the artwork, because this is something that they can own. But for me doing the intervention is the real joy.

In the book, you have included, next to the photos of the work, the length of time that the piece lasted in the location. This time seems to be quite significant for you. Would you say this is when the sculpture is "alive?"

Time is very important for me. I think time and sculpture are related, especially with this body of work that I call "Spontaneous Sculptures." For some of my works, I use video rather than photography.

There is a reason for this, which is that I would consider the entire time that passes while making the work to be the sculpture. The sculpture is the time when the physical objects are being manipulated; the situation left after is not the work, and I don't consider this action a performance. And this time that has passed, which is the sculpture, is also captured in a video.

Other works are captured with photography. For example, in Paving Slab Pry Stack (House of Cards III), the sculpture is the slabs of pavement made into something else. When the "house" is built, this is an artwork that people can view. But since these sculptures are later removed or destroyed or fall over, I need to document them in a photograph. see p. 151

There is a third aspect of time, in addition to the time elapsed in a video or the instant seen in a photo. And that aspect is that once I work with the materials, they become artistically "charged," so that they are, in a way, always part of a sculpture, for as long as they exist. Again, to use the example of House of Cards III, the paving slabs were pulled out of the ground, and, presumably, when the city repairs it, they put those exact same stones back in that same spot that I took them from. So actually, the time the sculpture exists, or is being created, is still run-

ning. You can still go and see the sculpture, but just reformed back into the city. It's been transformed twice and finally it becomes invisible again, or as visible as it ever was.

I think this is a good way to develop sculpture. Many people could possibly interact with the fabric of the city, and then the city could be much more flexible and dynamic. But so far nobody has picked up where I have left off. It has always been that I make a work from the materials of the city and another person puts them back to where they came from. But the putting back is still somehow a third form for the sculpture. Even if it looks the same as it did in its original state.

This reminds me of my daughter. In the morning everything is clean in my house and then she awakes and does her thing: takes things and builds something, combines stuff and throws this and that away. And then in the evening when she's asleep, it's my job to put everything back in its place. And every day it's the same. I feel like the construction worker who has to tidy up your playground. Does your work spring from a childlike energy?

Yeah, I am just trying to have fun. Walking around and keeping an open mind. I think children are best at this.

Do you ever attempt to put a theoretical framework around your practice?

No, I just go around looking for funny things. It depends on my mood. Sometimes I am pissed off, sometimes happy, sometimes sad.

When I look at the photos of the Spontaneous Sculptures, I also thought that your work relates to collage in the way you work with alteration. For example, see p. 144 **with Booth Pry (Dead), there is a telephone box that appears to have fallen over. One can see the gap in the pavement that has been left by the telephone booth. For me, this reminds me of collage, especially the process of separation. I see in your work many simple altering gestures. Like my daughter, you just take something and move it slightly, and then it's something different.**

Negative space is very important for me. It is at least as important as the positive space. A big challenge is how to rearrange the information that's already there to find new possibilities. Like I said before with House of Cards III the slabs that it was built from came out of the pavement, and they leave a shape which is another sculptural form, a negative space which adds another layer to the work. And this negative space was as carefully composed as the positive space of the house. In fact, I meant to reference both the shape of stealth bomber and a sculpture by Carl Andre titled Eighth Reversed Steel Corner.

What about responsibility? Are you concerned about your work being a hazard?

I always try as much as possible to make sure the sculptures are safe to be around. No one has ever been hurt by my work. At least I have not heard of anyone being injured since I started making outdoor works in 1998. I make sure that my works are not placed, for example, where somebody would ride their bike at night or where somebody could trip on them. I would never want my work to harm anyone.

You moved to Berlin four years ago and you told me then that you planned to move to my neighborhood. I walk around often and I expected to see works of yours to appear in this area. When I passed street signs that were altered, or road surfaces that had been changed, I thought to myself: "Maybe this could be an artwork by Brad Downey?" I often thought it was, but I never asked you. But I felt pleased anyway that things were changing in my neighborhood, and that you were out there every day changing things and taking care of things.

Do you have any examples?

One day I was eating some food and sitting on a concrete bollard looking at the street. I noticed a part of the road where cars are not allowed to park, with diagonal lines painted on the ground to mark it off. I could see some black tar had been put down and covered only some sections of the yellow lines. To me it looked like an artistic composition. I thought to myself that this is not just a

coincidence, and that it must be a work of yours. But now when I look at works in the book, I see that this composition in tar could have been an inspiration or a starting point for works such as Tape see p. 104 **Peel (Broken Bike Lane). When I see something that I think is a work of yours, how can I be sure it is by you and not by a construction worker or a child playing? Or is this important?**

It's not very important to me that you would be certain these situations are my artwork. What is more important is that, through having previously seen my work, people in the city are opened up to visually engaging with transitory moments in their city. I enjoy this aspect because my body of work becomes both extended and less defined. I want to extend the breadth of possibilities in my work to a place where the viewer is creating artworks on their own by imagining that something they come across was made by me. The possibility of these things being my work makes new artworks. There are many pictures and conversations about random things that happened in numerous cities which people think are my work, although they aren't. I am glad to see this, not because I can get undeserved credit for artworks, but because knowledge of my artwork has given people a new way of seeing artistic potential in their surroundings. I like that someone could be standing somewhere in a city, looking at a pile of stones, and thinking: "Maybe that's Brad Downey's work?"

So that brings up the issue of authorship. It seems it is not important to you?

Maybe that is what working in many different cities has taught me. But that's more about losing some faith in permanence or in leaving a legacy. Now the more I work outside, the more I realize that it's naïve to believe that you can make something permanent, and that this monument will carry your name forever.

What is your threshold for something to be a work? How do you judge its quality, or whether it is good enough for you?

It's just a feeling. For example, after going grocery shopping, I often lock two shopping carts together using a coin-operated lock and chain mechanism. They look to me like two lovers locked together. Even though it was quite nice to see two shopping

carts linked together, it never felt like something I needed to photograph. It was just something that was funny for me to leave at the grocery store each time. Maybe nobody ever noticed it. But as I do my shopping or as I go through my day I try to leave little things behind.

Then, in 2008, when I was in Amsterdam, I found a drawbridge with a chain hanging from it. At this moment I knew what my earlier "shopping cart lovers" were destined for, and that became the piece Cart Connect & Hang (Abelard and Heloise). see p. 46

When I looked at the photos in this book, I don't get the feeling that you were trying to take the perfect picture. It doesn't seem like you put a lot of energy into capturing the form itself; it's more like capturing the mood.

Sometimes they're even out of focus. It's most important to capture it. That's it. Get it and move on.

☺

Pole Connect (□)

2007, Stockholm, Sweden
Duration: 2 hours
Plastic tubes
In collaboration with Akim

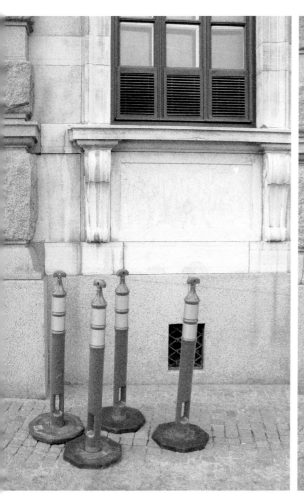

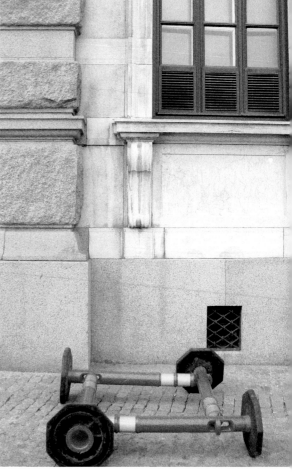

2005, London, U.K.
Duration: 14 minutes
Crossing barricades, cones
First photo by Julia Tingulstad

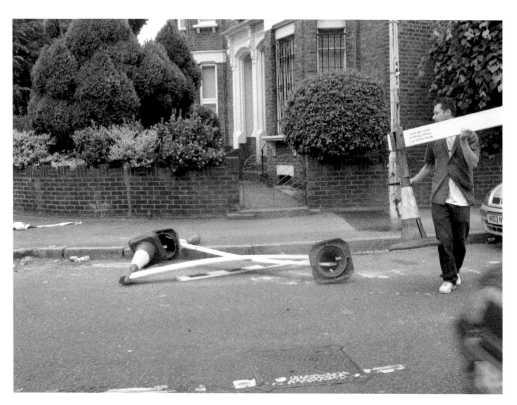

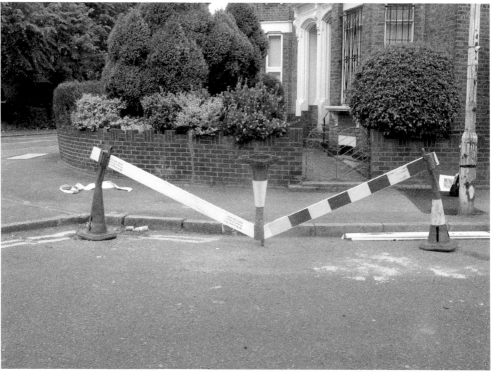

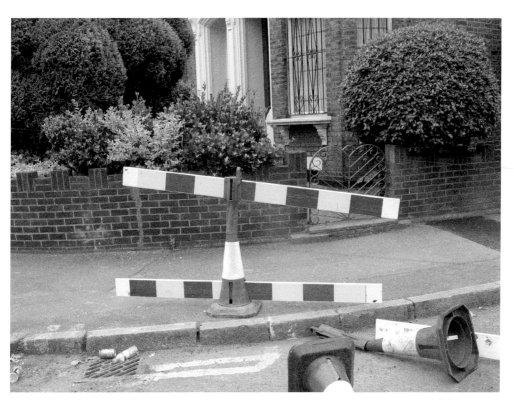

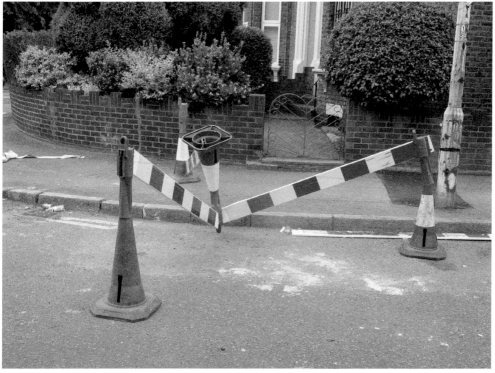

2009, Malmö, Sweden
Duration: 6 hours
Bike, benches
Made in a workshop for Spinneriet,
School for Urban Art

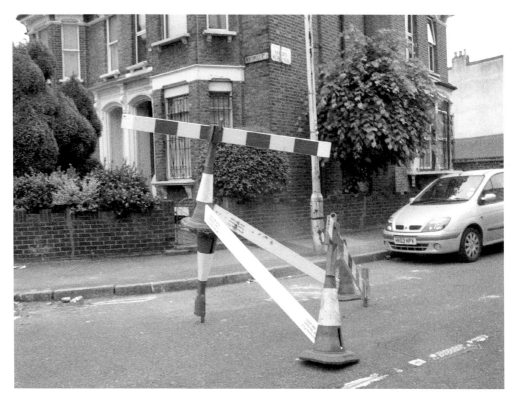

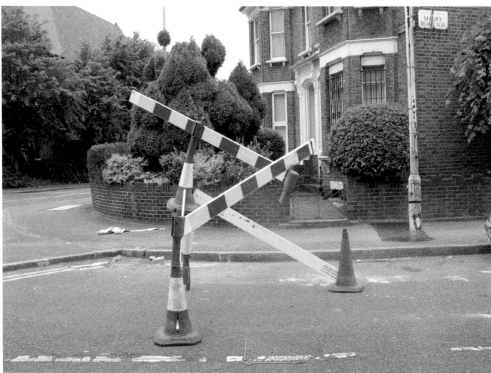

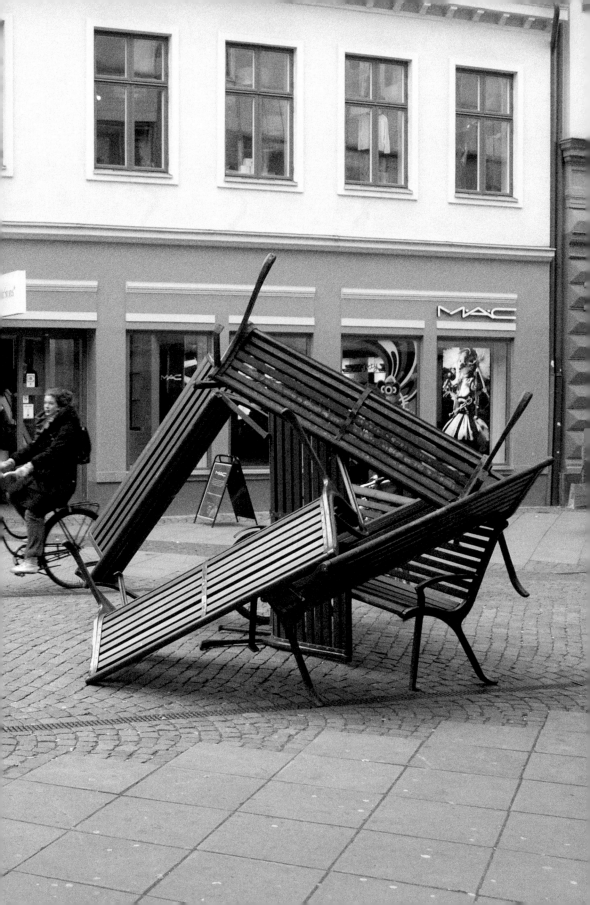

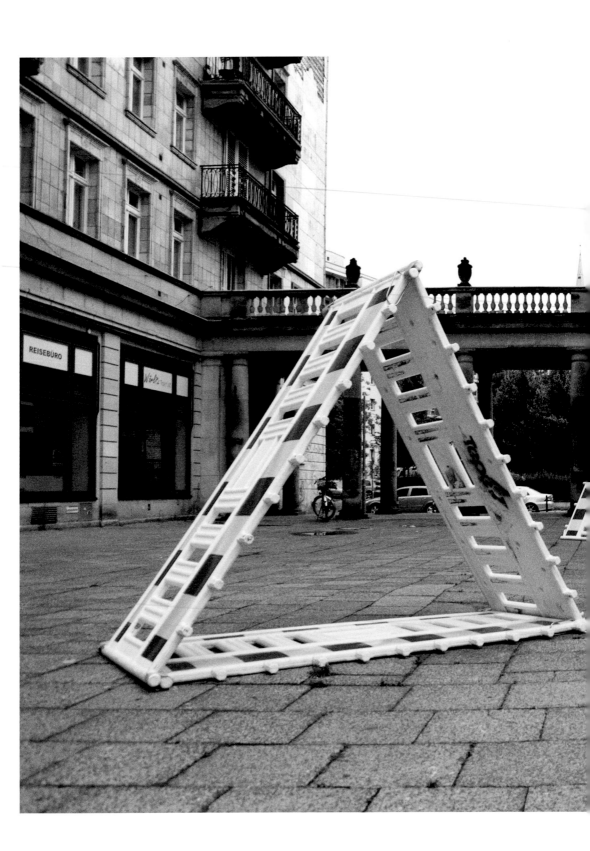

Barrier Stack (House of Cards)

2007, Berlin, Germany
Duration: 4 hours
Roll of gaffer tape, construction barriers
In collaboration with the JEW CREW (Giovanni Goldberg, Izaak Brinkmann, David Rubinstein & Abraham Downey)

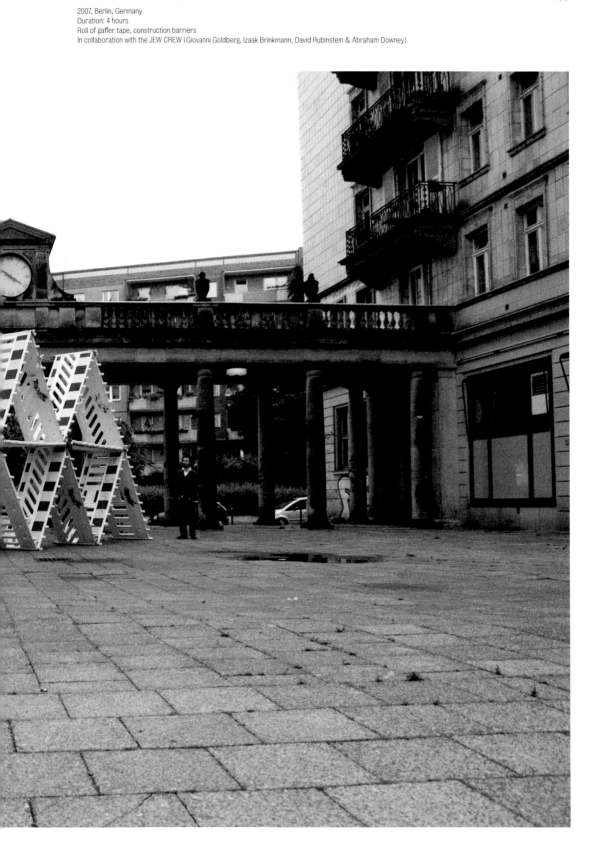

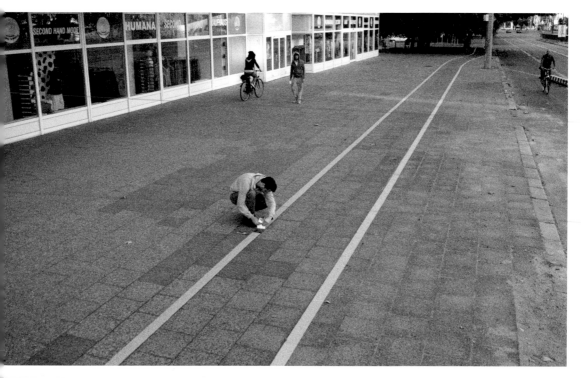

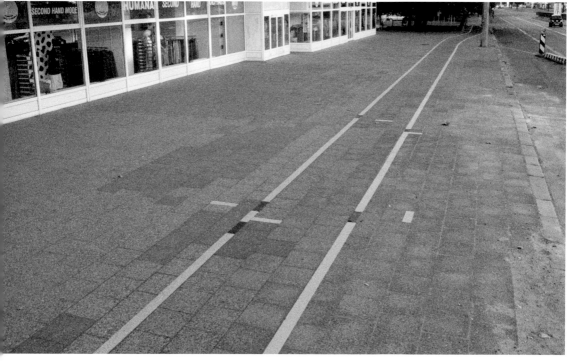

2008, Berlin, Germany
Duration: unknown
Road marking
Photos by Vincent Maigler

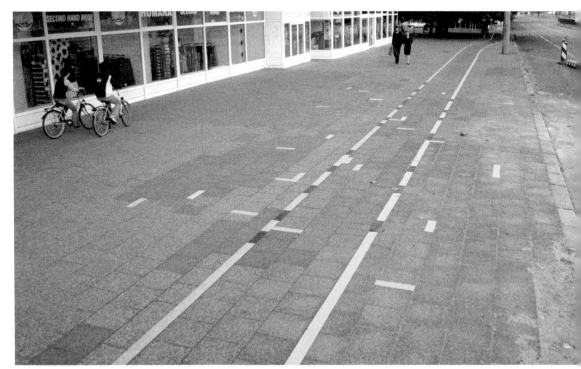

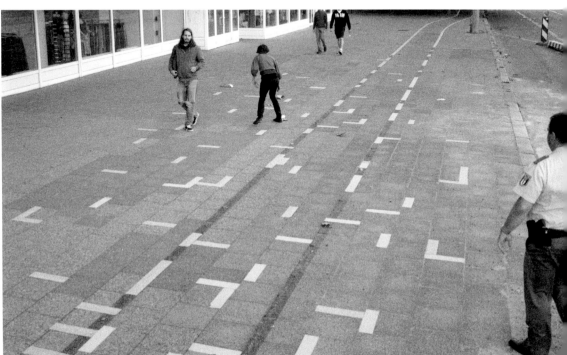

TV Cover (Hiding II)

2010, Seoul, South Korea
Duration: 10 minutes
Plastic sticker, TV

Bottle Wedge II

2009, Berlin, Germany
Duration: unknown
Underground U8 windowsticker, beer bottle
In collaboration with Try one and The Wa

next spread
(108–109) # Street Pole Lift (Leaning)

2010, Örebro, Sweden
Duration: 1 hour
Tape, bus stop sign

TRY, THE WA, Adrian and I were on our way home from Akim's birthday
party. TRY was showing us how easy it is to peel these, transparent, anti
graffiti, stickers off the U8 windows. THE WA pulled the sticker off. I stuck it
between these two poles and wedged my empty beer bottle.

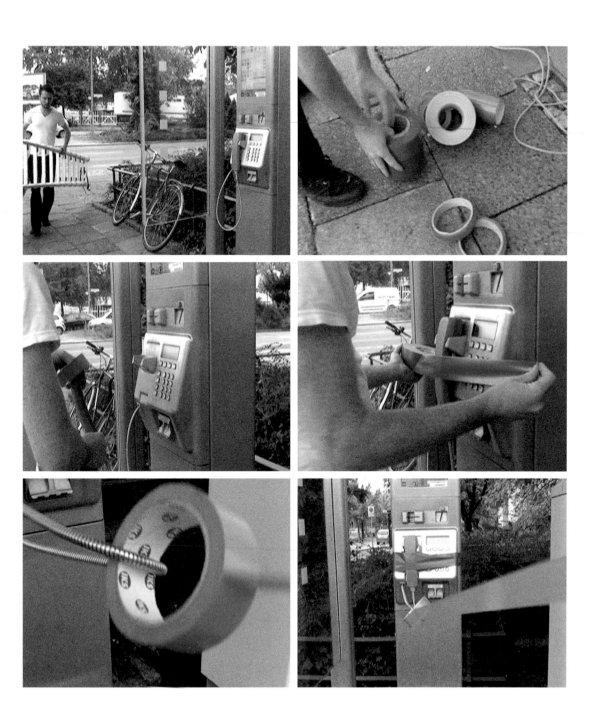

2008, Berlin, Germany
Duration: 1 day
Coloured tape, digital videostills
Photos by Just

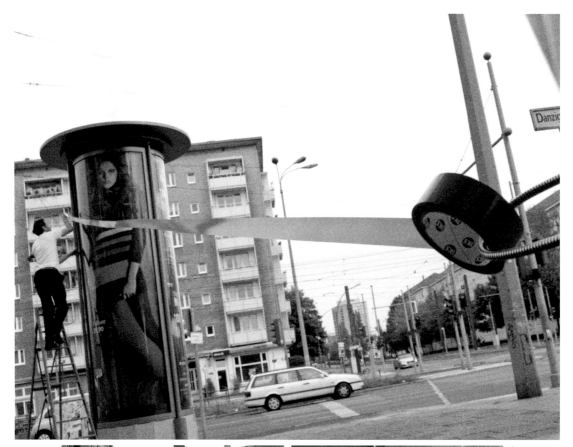

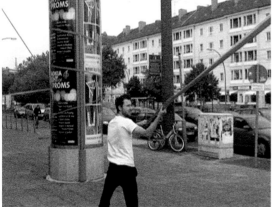

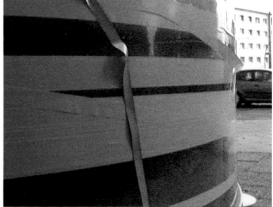

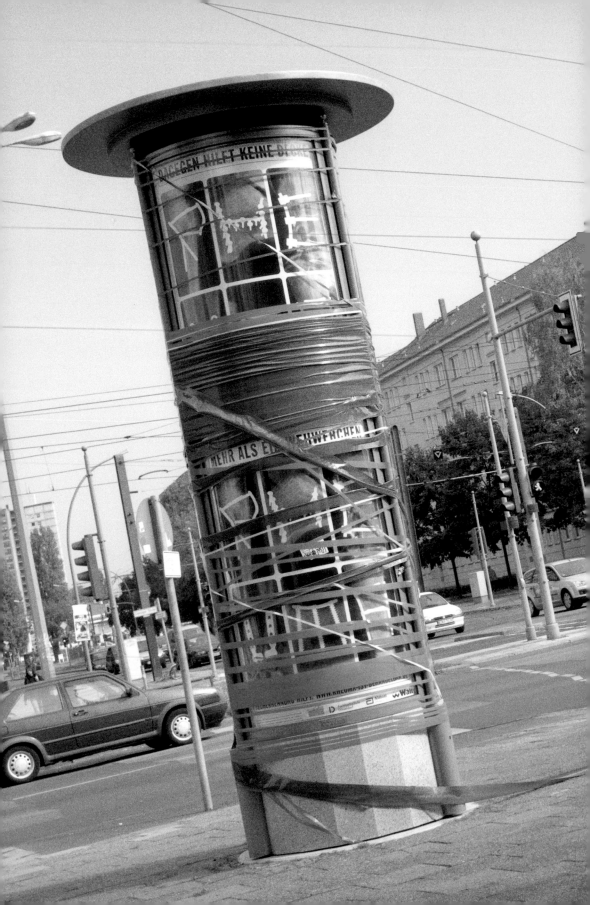

Tape Lift

2008, Amsterdam, Netherlands
Duration: 14 hours
Electricity marking tape

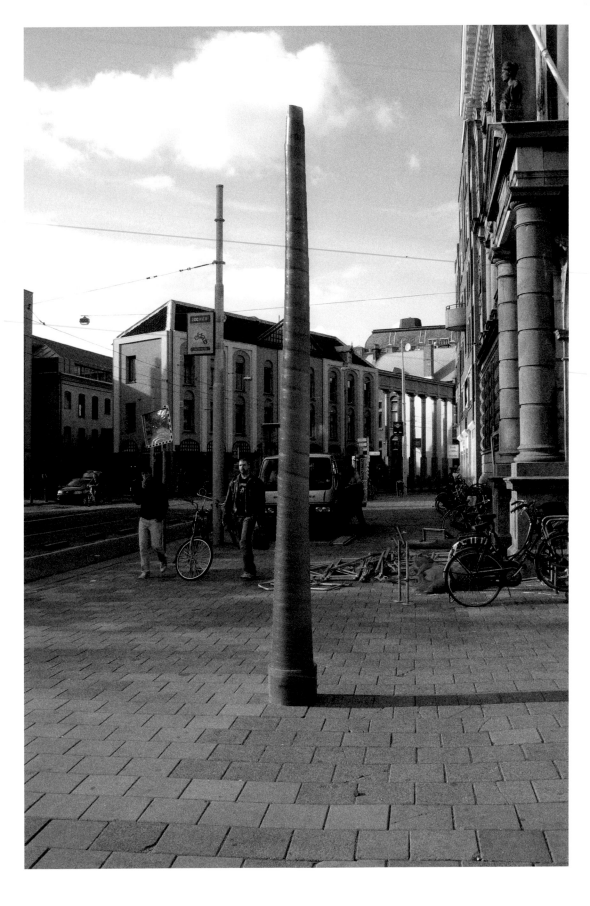

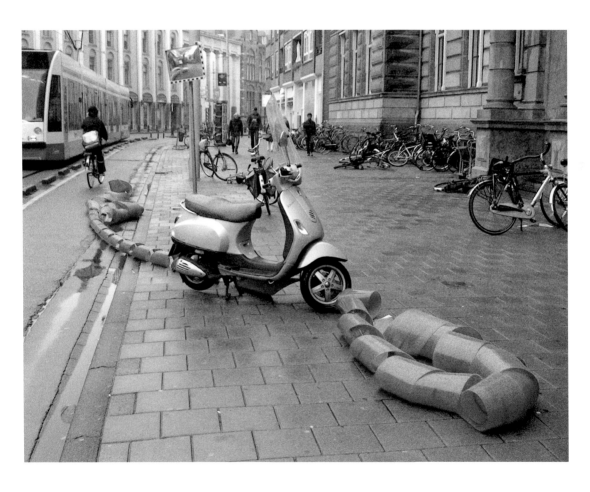

Pipe Bend

2011, New York, USA
Duration: 2 months
Handrail

2011, Dubai, UAE
Duration: unknown
Fence

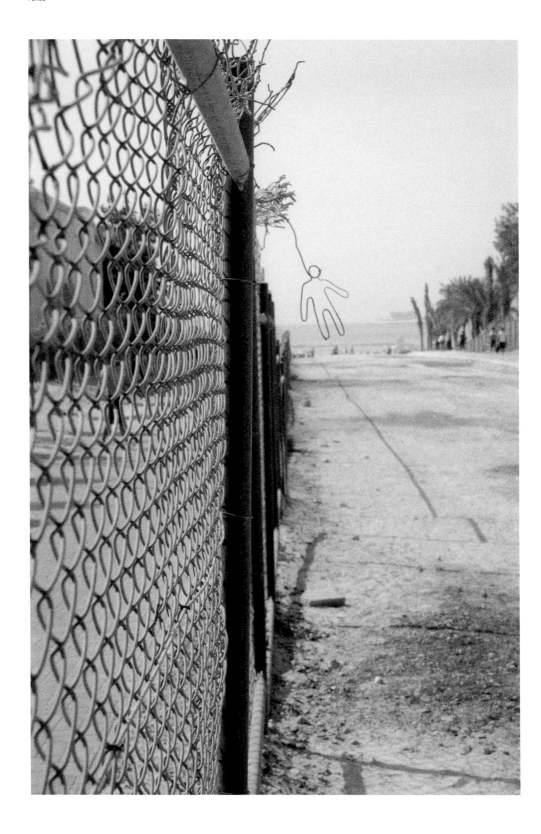

Tube Bend Wedge (:) :()

2008, Amsterdam, Netherlands
Duration: 25 minutes
Plastic tube
Made in workshop with Sunnhordland Folkehogskule

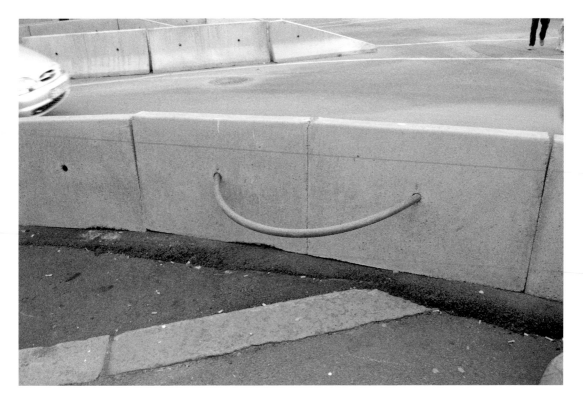

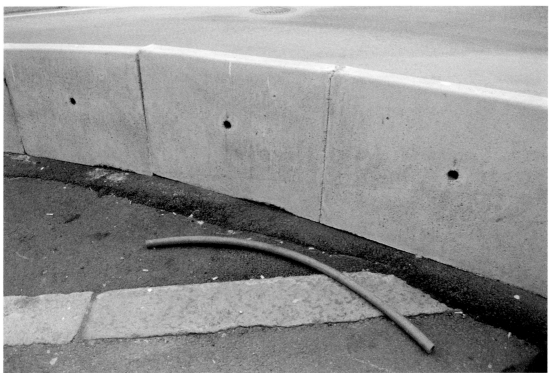

2008, Amsterdam, Netherlands
Duration: 12 hours
Plastic tubes

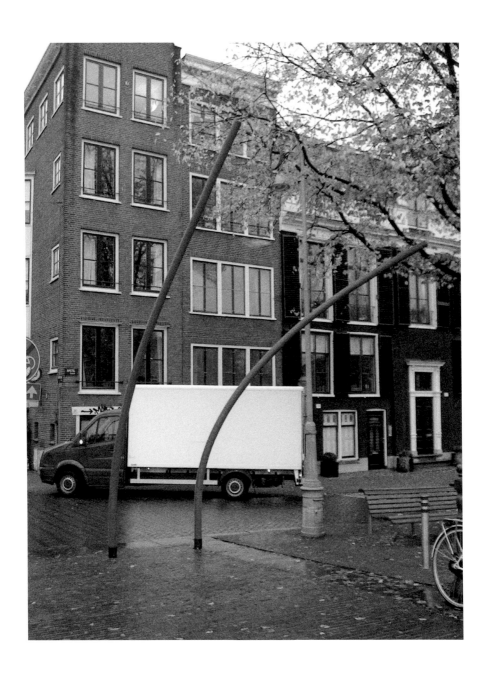

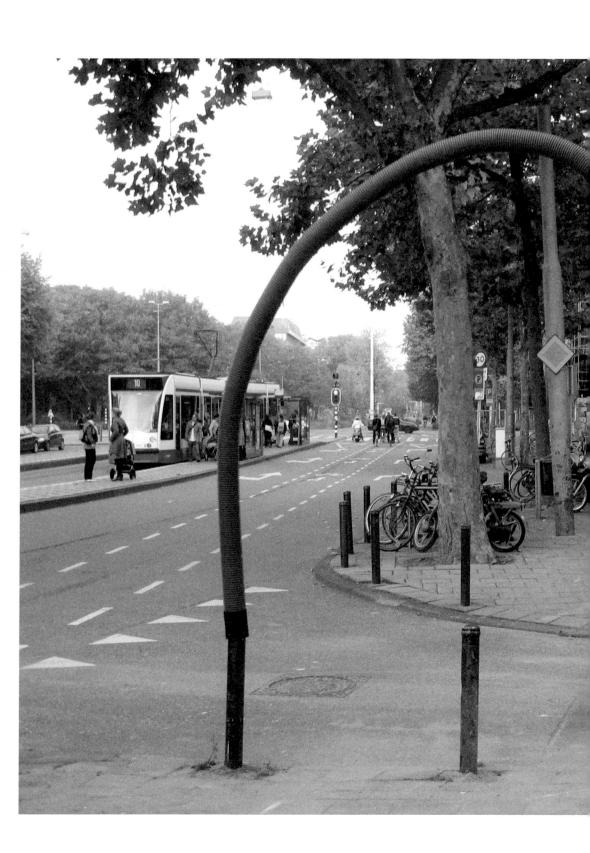

2008, Amsterdam, Netherlands
Duration: 6 hours
Plastic tubes

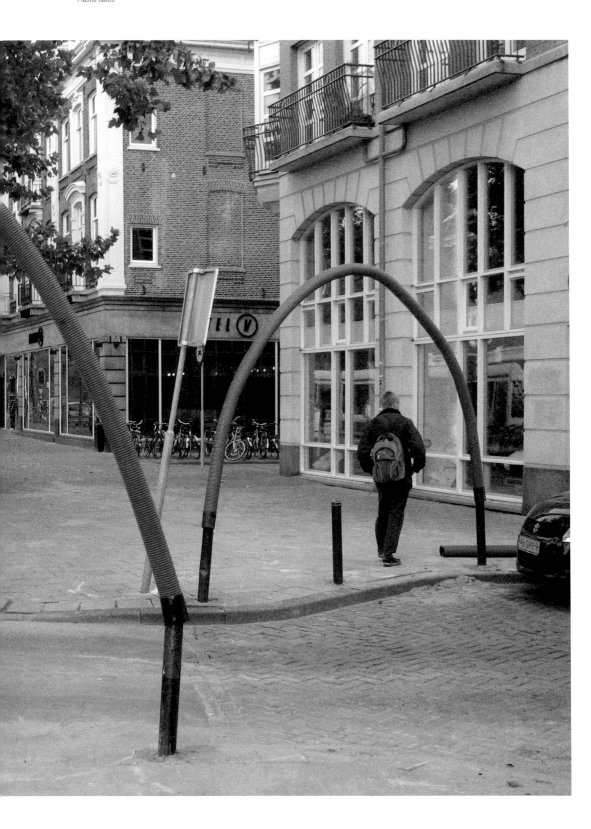

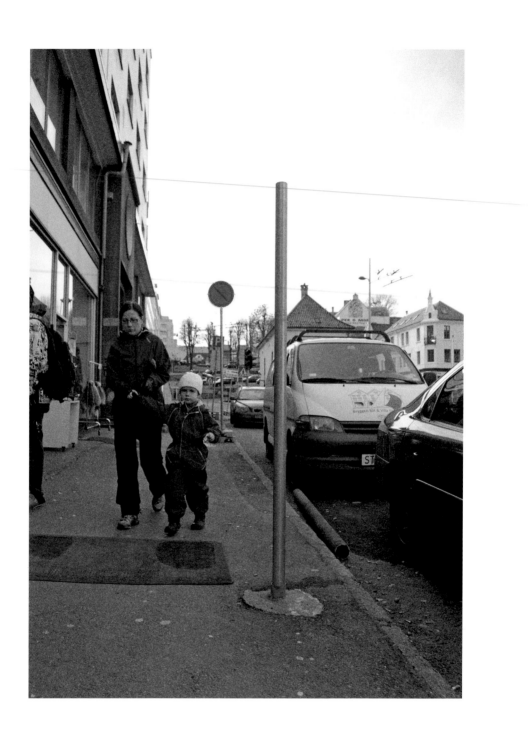

2010, Bergen, Norway
Duration: 7 hours
Plastic tube

Bollard Bend (Limping)

2010, Seoul, South Korea
Duration: 1 hour
Bollard, tape

next spread
(128–129) Bollard Bend II (Love)

2010, Seoul, South Korea
Duration: 2 hours
Bollards, tape

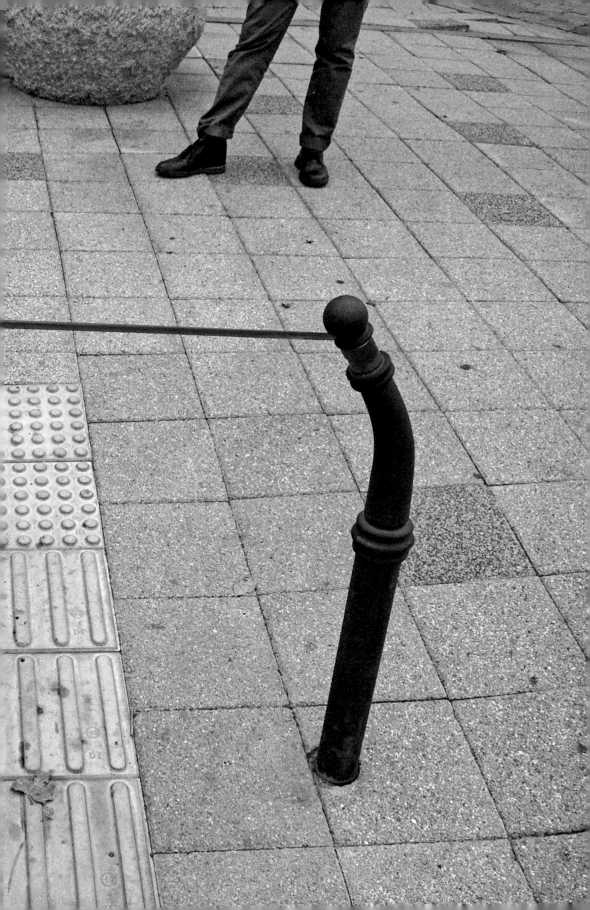

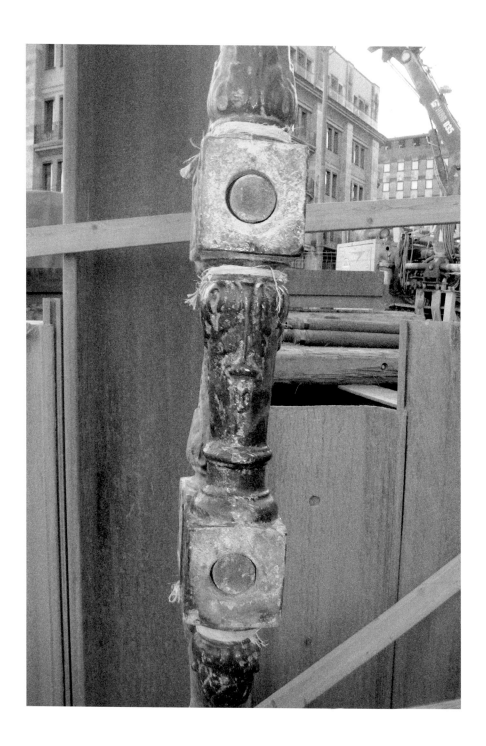

2007, Stockholm, Sweden
Duration: 3 days
Bollard with broken marble, three strings, gravity
Special thanks to Akim, THE WA and Daniel
That pole and marble were mad heavy. And Daniel was mad strong.

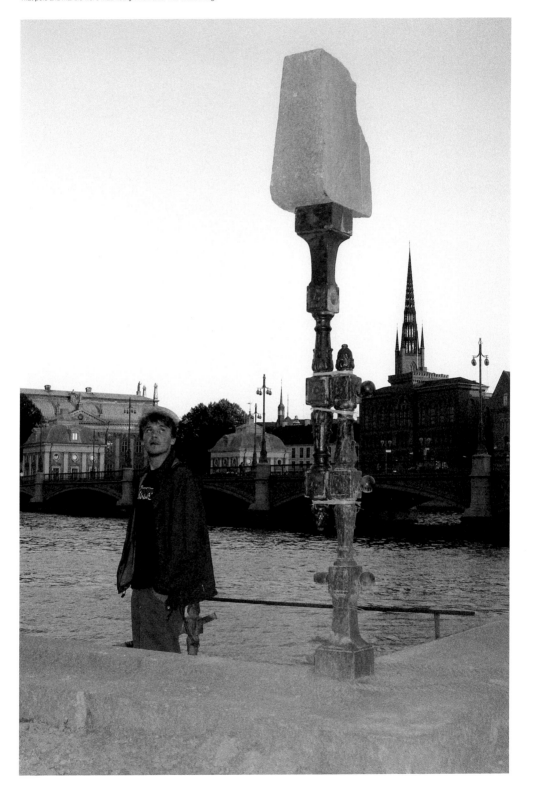

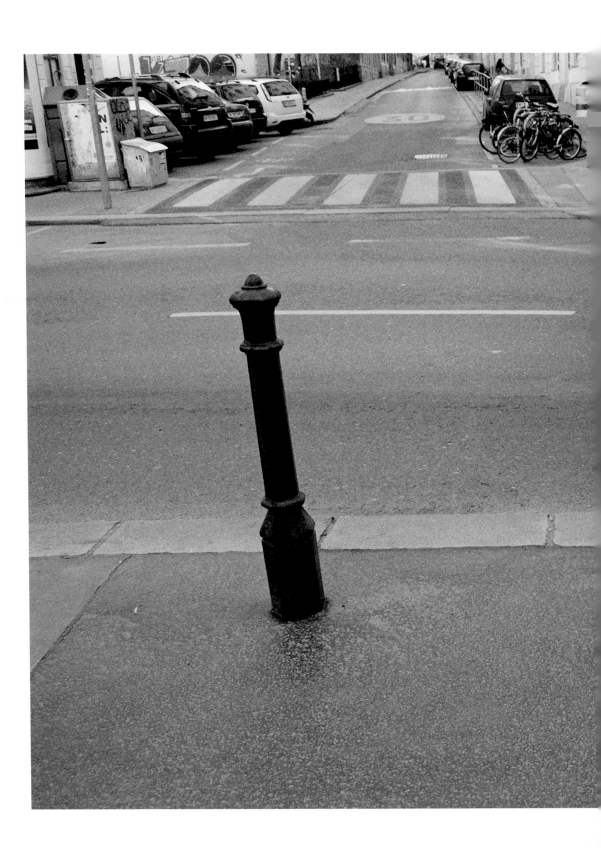

Bollard Cover (Chess)

2010, Vienna, Austria
Duration: 2 days
Bollard, shaving foam

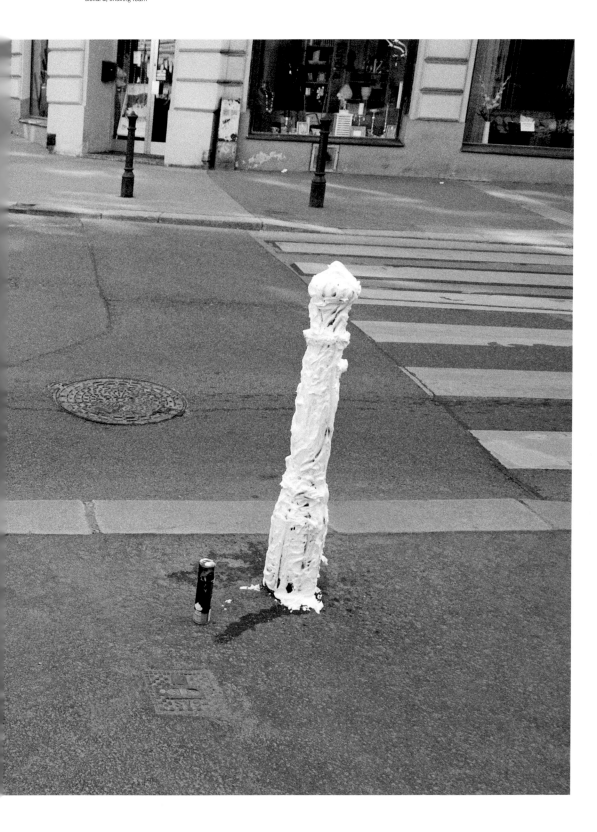

Bollard Cover II

2010, Berlin, Germany
Duration: 12 minutes
Broken bollard, wire

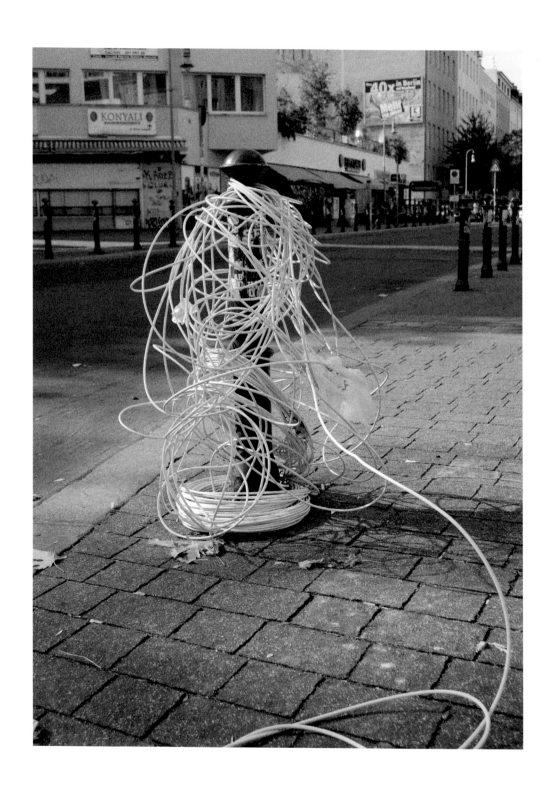

2010, Vienna, Austria
Duration: 2 months and counting
Broken bollard, wood, wire

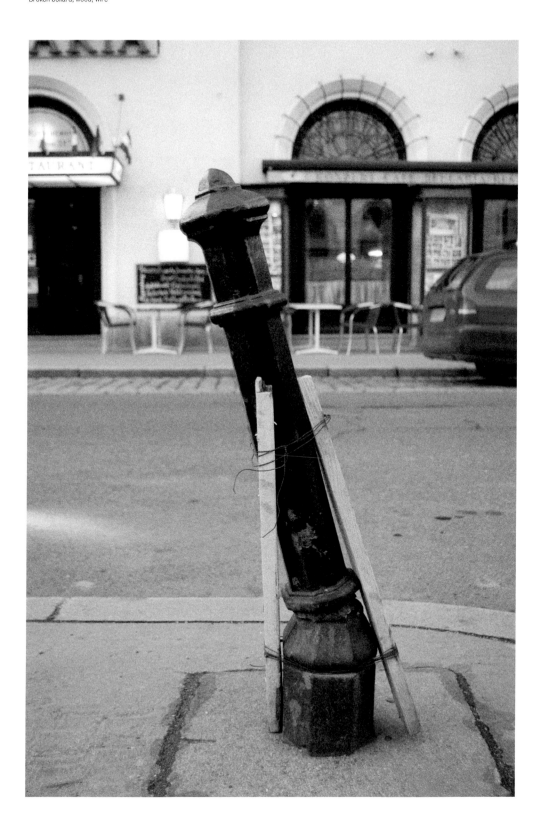

Bollard Bend III (Cannons)

2008, Berlin, Germany
Duration: 3 weeks
Bollard
Dedicated to Ricky Oyola (Eastern Exposure III)

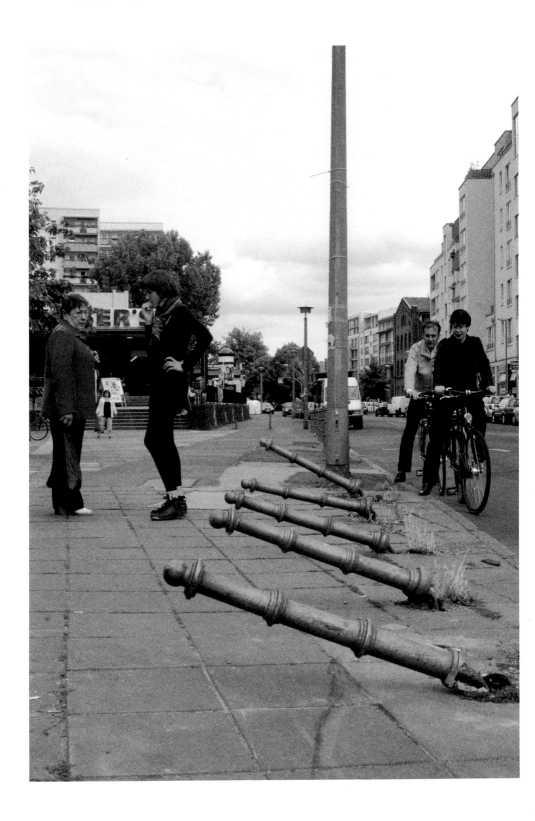

Bike Flip

2011, Berlin, Germany
Duration: 2 minutes
Bikes
Dedicated to Ariel Schlesinger

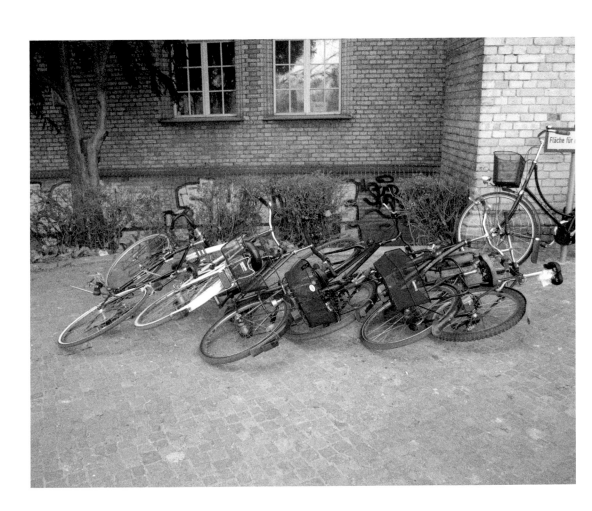

Curb Lift

2008, London, U.K.
Duration: 2 hours
Curb block
Photos by Matt Murphy

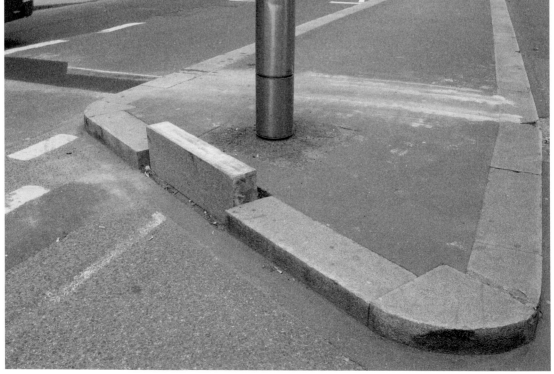

2010, Vienna, Austria
Duration: 2 months
Electrical box

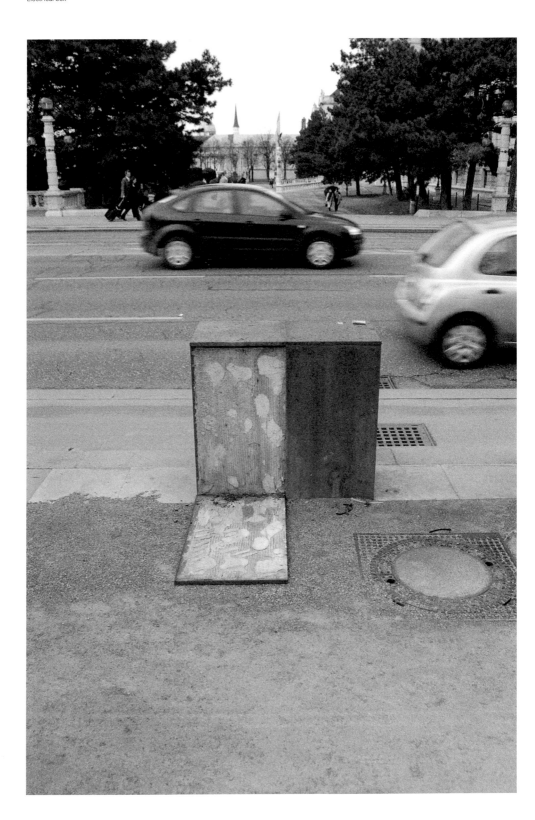

Tile Pry (Gentrification)

2008, Amsterdam, Netherlands
Duration: unknown
Tiles

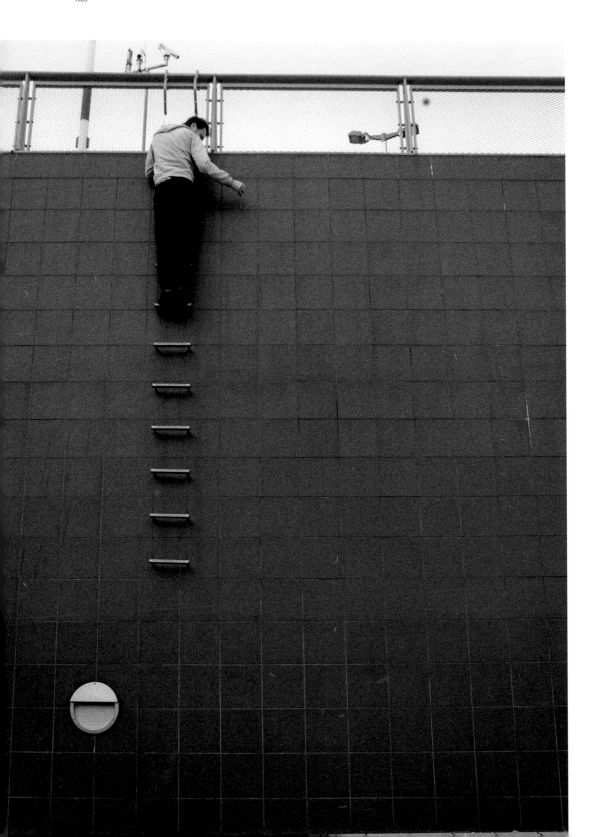

2005, London, U.K.
Duration: 2 days
Big balls, phone booth

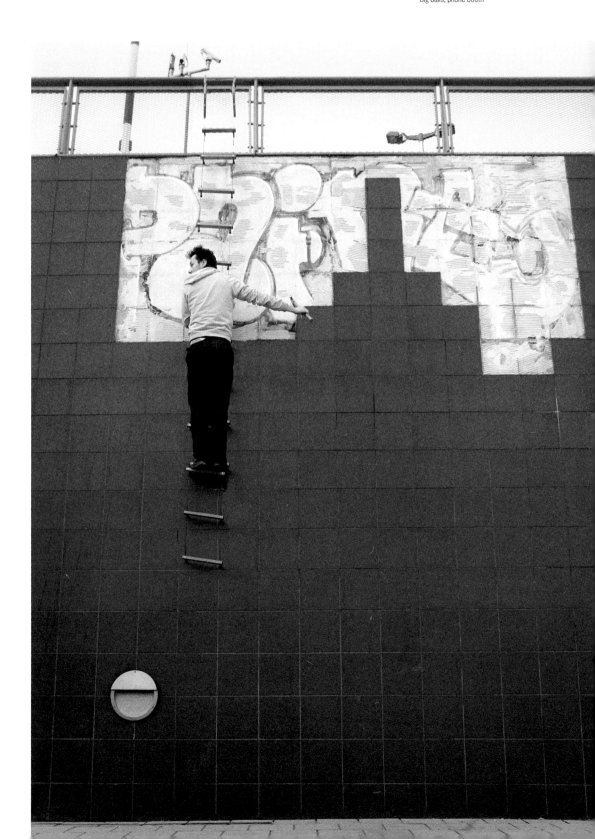

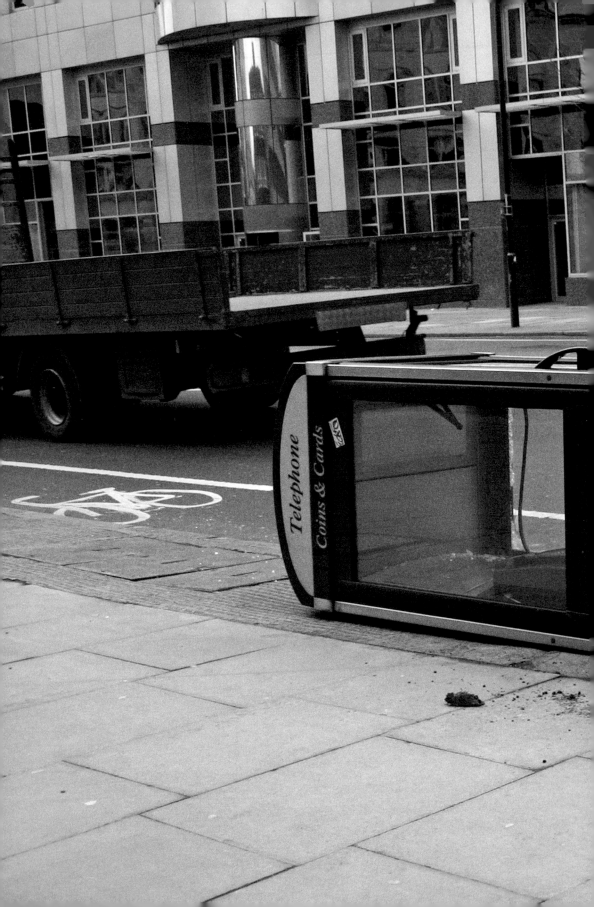

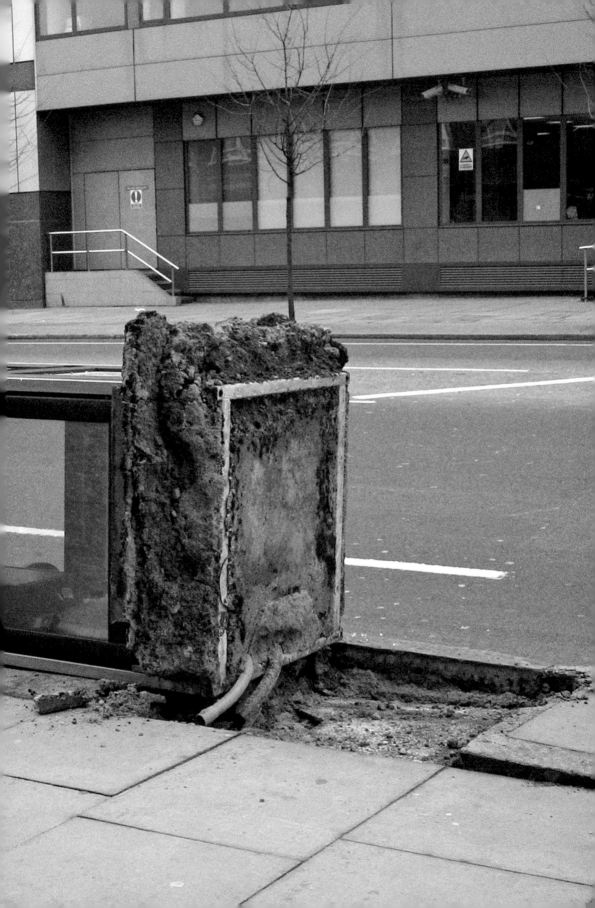

2011, Lisbon, Portugal
Duration: 2 weeks
Paving stones, lift

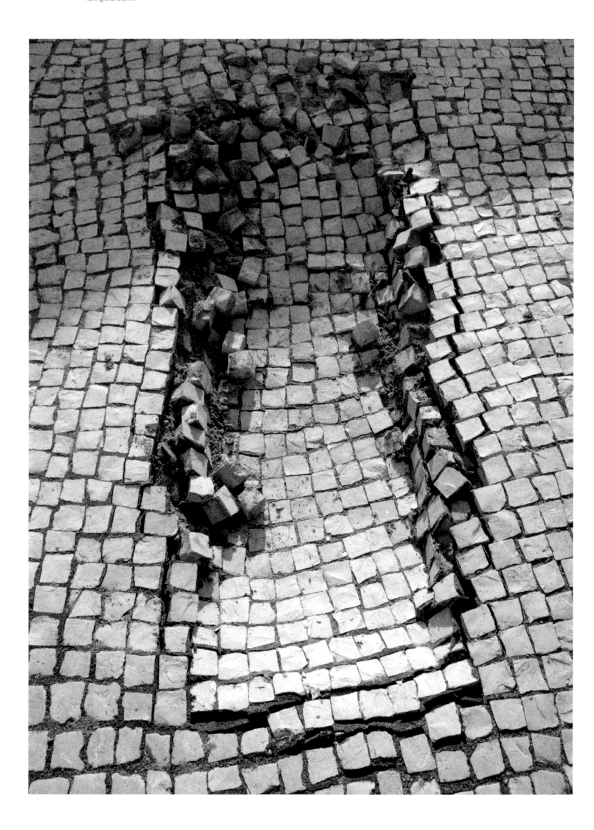

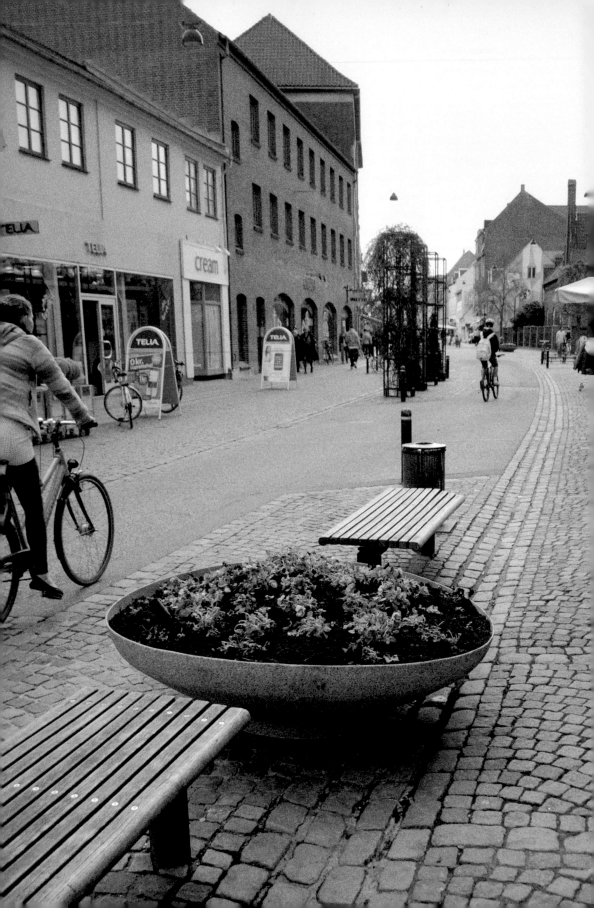

2010, Roskilde, Denmark
Duration: 6 hours
Dirt, plastic pot, flowers

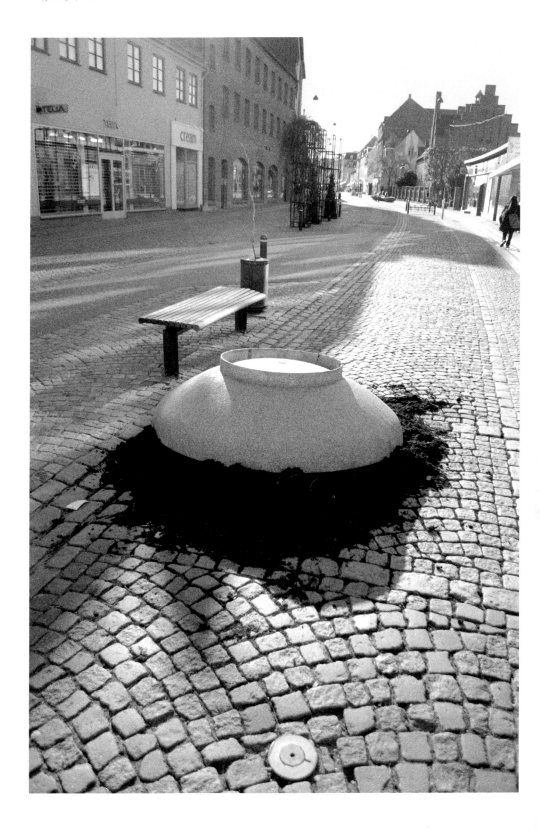

Paving Stone Stack (Wishing Well)

2007, Stavanger, Norway
Duration: 4 hours
Paving stones, children's dreams
Made in a workshop for Nuart 2009
Photo by John Paul Cunningham

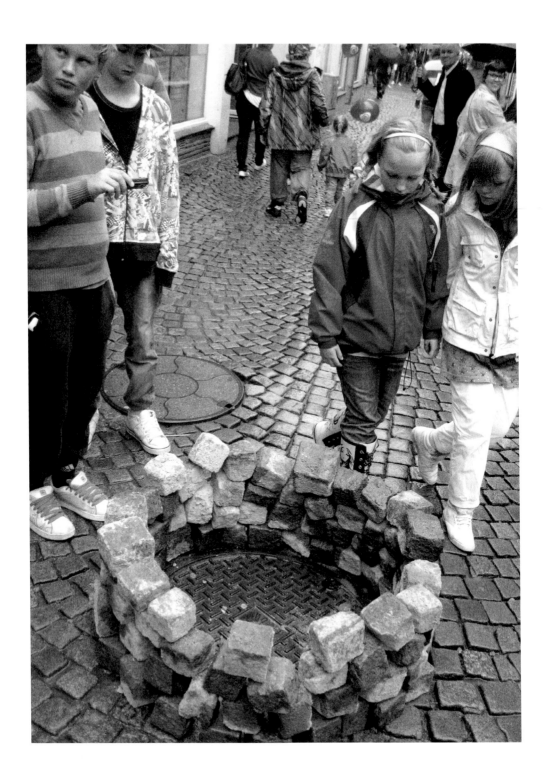

Paving Slab Pry Stack (House of Cards III)

2007, Berlin, Germany
Duration: 4 days
Paving stones

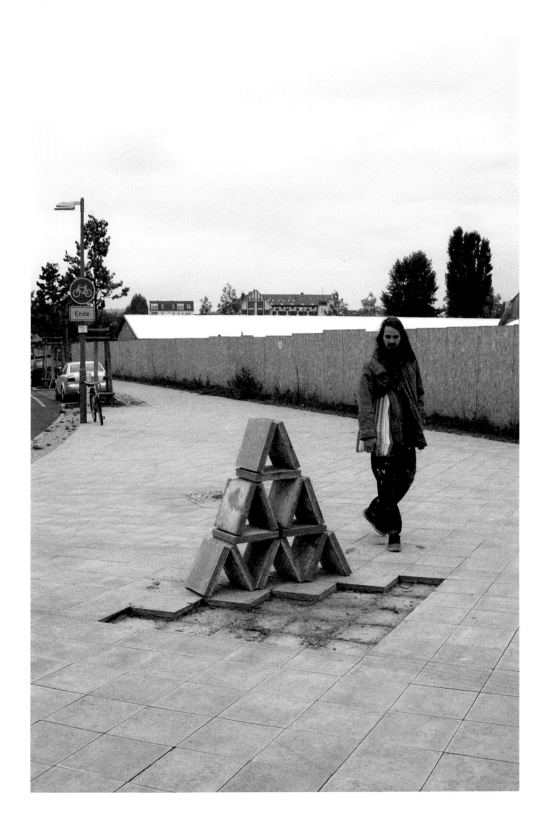

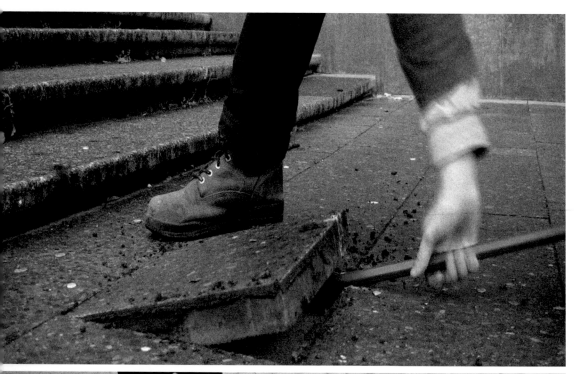

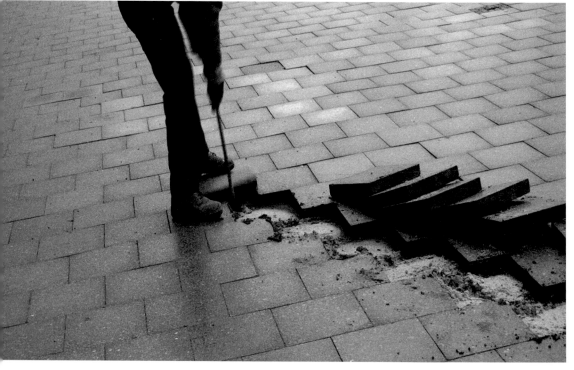

Paving Slab Pry Shift (Un-Stitching Karl)

2007, Berlin, Germany
Duration: 6 hours
Crowbar, pavement stones, digital videostills

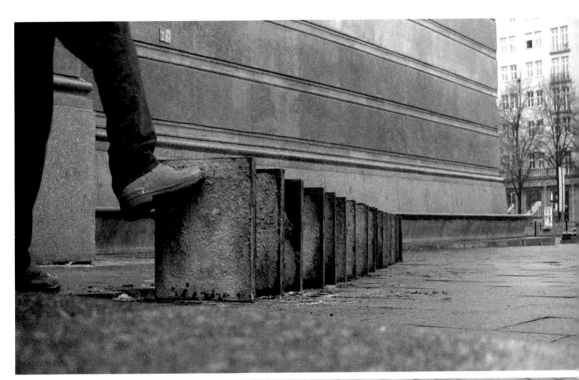

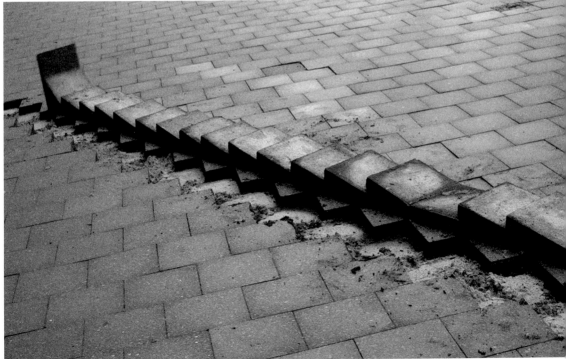

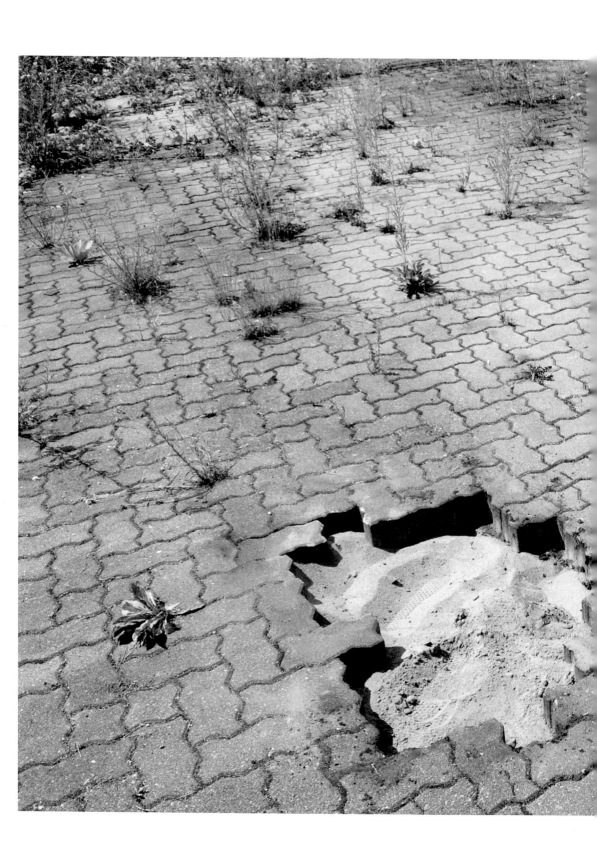

Brick Pry Stack (Wall)

2010, Hamburg, Germany
Duration: 2 days
Flathead screwdriver, paving bricks

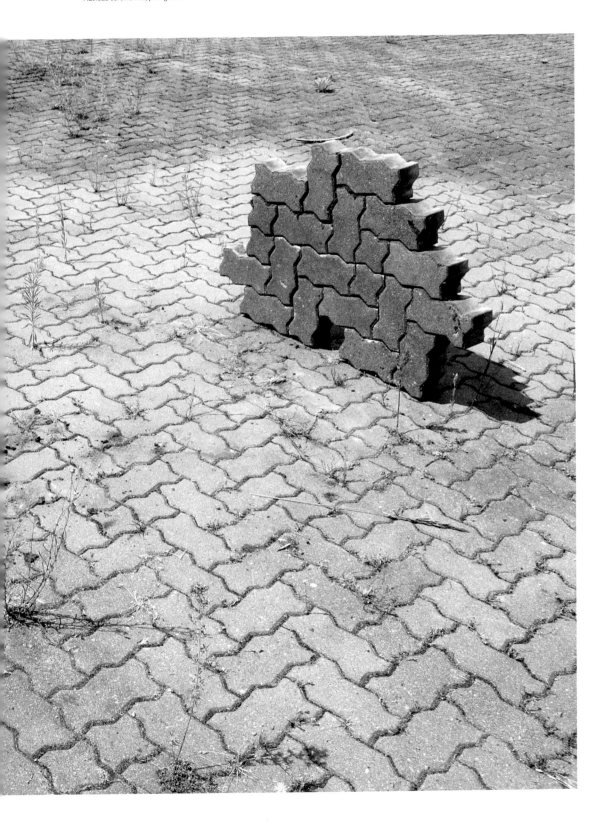

Paving Stone Stack II (Pyramid II)

2011, Lisbon, Portugal
Duration: 3 days
Paving stones

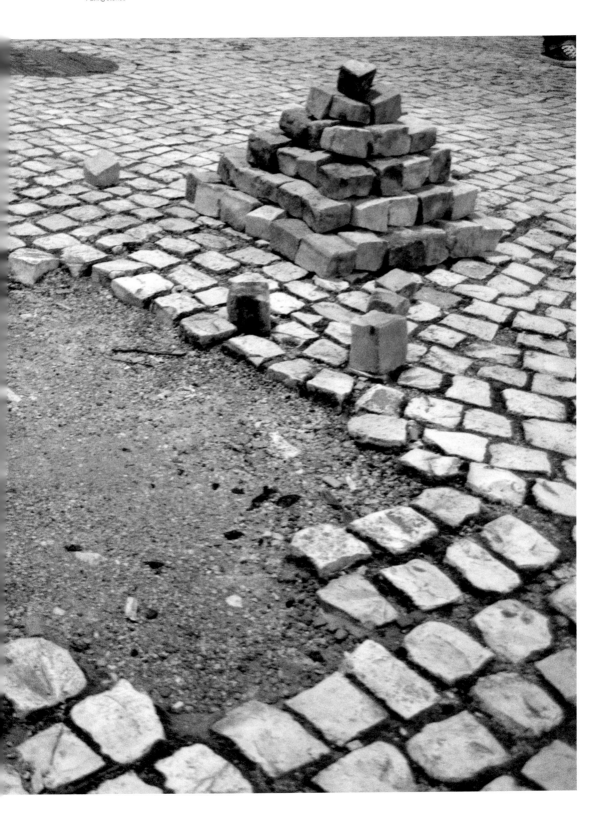

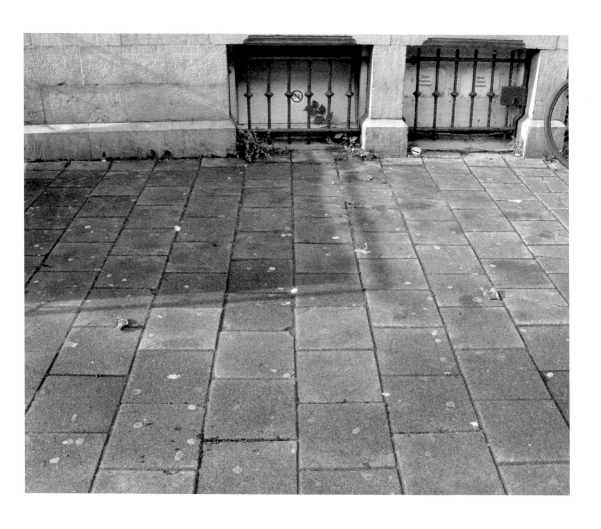

2008, Amsterdam, Netherlands
Duration: 2 days
Paving bricks, sand

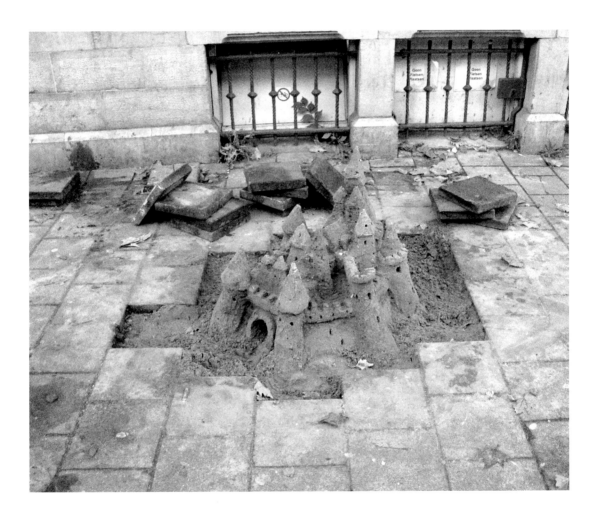

Brad Downey
Spontaneous Sculptures

Edited by Matthias Hübner, Brad Downey, and Simon Becker

Texts by Mel Gooding and Jennifer Thatcher
Interviews by Chiara Santini Parducci and Thomas Bratzke, edited by Matt Murphy

Brad would like to thank: Mom and Dad for unconditional love and blind support. Amber Downey, StepOnMe Downey, Simon Becker, Matthias Hübner, Matthew Murphy, Jennifer Thatcher, Monika Vykoukal, Chiara Santini Parducci, Adrian Nabi, Louise Drubigny, THE WA, Lucia Sotnikova, Alain Bieber, Jesus aka Stephan Bresinski, Thomas Bratzke, Lisa Marie Troppa, Mel Gooding, Bruce McLean, Rik Reinking, John Paul Cunningham, Jerome Fino, Morrissey, Carolin Oetzel, Vincent Maigler, Swoon, King Rollo, Darius Jones, Akim, Akay, Quenell Jones, Japanther, Ed Zipco, Ignatius J. Reilly, Jürgen Große, and Michalis Pichler

Sign City (pp. 4–5)
First printed in Bruce McLean: <u>Pavilions for Nothing, Rooms for Redundant Gestures</u>, Vestsjaeiiands Kunst Museum, Soro, Denmark 1993.
* "brick" from dictionary.com

Layout by Simon Becker and Matthias Hübner

Project management by Elisabeth Honerla for Gestalten
Production management by Vinzenz Geppert for Gestalten
Proofreading by transparent Language Solutions
Printed by Main Choice
Made in Asia

Published by Gestalten, Berlin 2011
ISBN 978-3-89955-379-6

MIX
Paper from
responsible sources
FSC® C020691

myclimate
Protect our planet

Brad Downey

was born in 1980 into a military family. He studied Film at Pratt Institute, Brooklyn, and Painting, at the Slade School of Art, London. He currently resides in Berlin, Germany.

Mel Gooding

is an art critic, writer and exhibition organiser. He graduated with an MA (English) from the University of Sussex in 1966. He has written many catalogue texts and has contributed extensively to the art press, and to magazines and newspapers.

Jennifer Thatcher

is a freelance critic and a regular contributor to Art Monthly, ArtReview and MAP magazines. She currently works part-time as project co-ordinator for the 2011 Folkestone Triennial, the UK's largest festival of newly commissioned public art. Jennifer was Director of Talks at the ICA, London (2003–9), and Managing Editor of contemporary magazine (2001–3)

Chiara Santini Parducci

Is a freelance curator. She currently works full time as the director of Oxylane Art Foundation in Berlin (2011). Chiara was the manager of Galerie Du Jour Agnès B, Paris. She graduated from New York Film Academy and Università di Pisa.

Thomas Bratzke

is an artist living and working in Berlin. He was involved in the early stages of the city's graffiti scene, writing "Zasd," and followed this with studies in sculpture and liberal arts at the University of Fine Arts Weissensee in Berlin. He organized at The City of Names exhibition in 2005 and has received commissions for artworks across Europe.